IMAGES
of America

ARMENIANS OF THE
MERRIMACK VALLEY

On the Cover: Sebou Devejian operated a grocery store at the corner of Washington Street and Washington Avenue near the B&M station in Haverhill. He was born in Armenia in 1890 and died in 1969. Devejian and his wife, Arouseag (1900–1988), had one son, Anthony, born in 1928. (Courtesy of Toni [Devejian] Bevilacqua.)

IMAGES
of America

ARMENIANS OF THE MERRIMACK VALLEY

E. Philip Brown and
Tom Vartabedian

ARCADIA
PUBLISHING

Copyright © 2016 by E. Philip Brown and Tom Vartabedian
ISBN 978-1-4671-1561-2

Published by Arcadia Publishing
Charleston, South Carolina

Printed in the United States of America

Library of Congress Control Number: 2015948917

For all general information, please contact Arcadia Publishing:
Telephone 843-853-2070
Fax 843-853-0044
E-mail sales@arcadiapublishing.com
For customer service and orders:
Toll-Free 1-888-313-2665

Visit us on the Internet at www.arcadiapublishing.com

Dedicated to the victims of the Armenian Genocide
Թող նրանց հիշողությունը լինել հավերժ
Anonts heshadagh haverzh togh mna.
(May their memory be eternal.)

Contents

Acknowledgments		6
Introduction		7
1.	The Armenian Family Bond	11
2.	Preserving Faith	27
3.	Employment, Business, and Industry	41
4.	Athletic Accomplishments	59
5.	Dealing with the Tragedy of Genocide	69
6.	Celebrating Armenian Culture and Tradition	87
7.	Dedication to Community	101
8.	Defending Home and Homeland	111

Acknowledgments

We would like to express our feeling of gratitude toward all of the individuals, families, and organizations that helped make this project a reality. In particular, we would like to thank the *Armenian Weekly* for providing access to information about the Armenian community in the Merrimack Valley. We also owe special thanks to Project SAVE Armenian Photograph Archives, the Armenian Museum of America, Andover Historical Society, and Newburyport Public Library for the assistance they gave us in accessing research materials. The religious community was very helpful in providing materials, especially Ara Jeknavorian, the Armenian Church at Hye Pointe, Sts. Vartanantz Church, and St. Gregory Church of Merrimack Valley.

INTRODUCTION

As Armenians throughout the Merrimack Valley join together in commemorating the 100th anniversary of a genocide in 1915, the future remains as prominent a fixture as the past. Time makes a habit of healing wounds but not forgiving. The loss of half their nation to Ottoman Turkey cannot dilute the strength Armenians have as a civilization that dates back 3,000 years and is said to be the birthplace of the human race, with the landing of Noah's Ark on Mount Ararat.

Since the turn of the 19th century, the Merrimack Valley has proven a stomping ground for Armenian immigrants. They built churches, rallied around clubhouses, kept their language intact, and nurtured their families. Education reigned foremost in their lifestyles. "Go to school and become a man," was common rhetoric in Armenian families. And they were aggressive. The first female president of a student class at Haverhill High was an Armenian who is today a lawyer. A 40-year instructor at a middle school hardly ever missed a day and spends his retirement visiting a relative inside a nursing home almost daily. A principal in Chelmsford was so revered he has an athletic field named in his honor. A 91-year-old earned a college degree this year.

The work ethic was also innately tied to the culture. A barber in Mount Washington in Haverhill sent a son to Harvard who prominently served in the field of law for over 50 years. A lowly shoe worker became an entrepreneur by turning a service station into the biggest auto dealership in New England. He started a dynasty by buying a manufacturing plant, hiring others of his kind, and letting generations follow in tow.

Armenian faces reflected hope, courage, and perseverance. They became writers, photographers, musicians, doctors, educators, farmers, business moguls, and the political elite. And they continued to shoulder the burdens of tribulation, despite adversity. They have remained guardians of their culture and timeless ambassadors toward their heritage.

They were relentless in their quest against annihilation in 1915. What is not so obvious is its role in history. In the mid-1890s, Armenians lost 300,000 victims to another Turkish regime. In 1909, there was a massacre of between 25,000 and 30,000 Christian Armenians in Adana. Soviet rule lasted seven decades from 1921, ending with an earthquake that killed around 30,000 Armenians in 1988. Three years later, the country established a democratic state. During these hard times, Armenians looked to the Merrimack Valley for refuge, and the door was wide open. It was not uncommon to see two survivors rekindle a friendship that developed in their native land from the very same village and maybe the same street. To them, Armenia has not been fragmented but rather immortalized.

In 1965, the valley housed around 70 genocide survivors. The last—Nellie Nazarian—died a year ago, weeks after making her presence felt at an observance in Lowell amid the rain. A wheelchair did not keep her from providing a wealth of inspiration that day. Seeing a cadre of survivors gathered together with candles in hand, exercising their language, was indeed invigorating inside an American-born audience.

Armenia's quest for justice has been faced with the refusal of the American government to properly acknowledge the genocide, due to strategic ties with Turkey. Through assimilation and political chaos, apathy and chagrin, Armenians have advanced, unflappable in their progress. They have stood firm in solidarity, determined to become productive and proud citizens and with pride in their ancestry. That pride also led more than 50 patriots well-entrenched in American security to fight for Armenia during World War I. Many never returned.

Detours have often led to paths of righteousness. A given Sunday inside an Armenian church in Merrimack Valley offers prayers and hymns dating back over 1,700 years. At one time, the valley was home to four Apostolic churches, a Protestant denomination in Haverhill, and another in Salem, New Hampshire. If anything has created enrichment and cohesiveness, it has been the church.

The birth of new generations, conscious of their identity, continues to bring new meaning and hope for a distressed population. Moreover, genocide education in schools throughout the Merrimack Valley has crafted new and vital connections, with non-Armenian students acting as ambassadors toward the cause. Some have appealed to the postmaster general for a commemorative stamp. Twenty pieces of artwork from Wilmington were sent to the government as logical examples for minting; however, they were denied.

In this centennial year, more than 15 schools received the benefits of human rights education in the Merrimack Valley, along with a number of service clubs, libraries, and civic groups. Most were unaware of and incredulous at Armenia's poignant history.

Armenians have taken initiative against uncalculating odds and made the most of opportunity. Like a phoenix rising from the ashes, the Armenians kept their resilience intact through difficult times. And they have done it with the intensity of hope and pride above despair.

With this book, we hope to share some of the more inspiring moments Armenians have cultivated in the Merrimack Valley. These stories are proof that bondage and turmoil cannot deprive a nation bent on prosperity. Consider this book as a shining example of how a people and a nation can be reborn. Regard it as a testament to the many who have shaped and molded the Armenian community without fanfare. The story lives on.

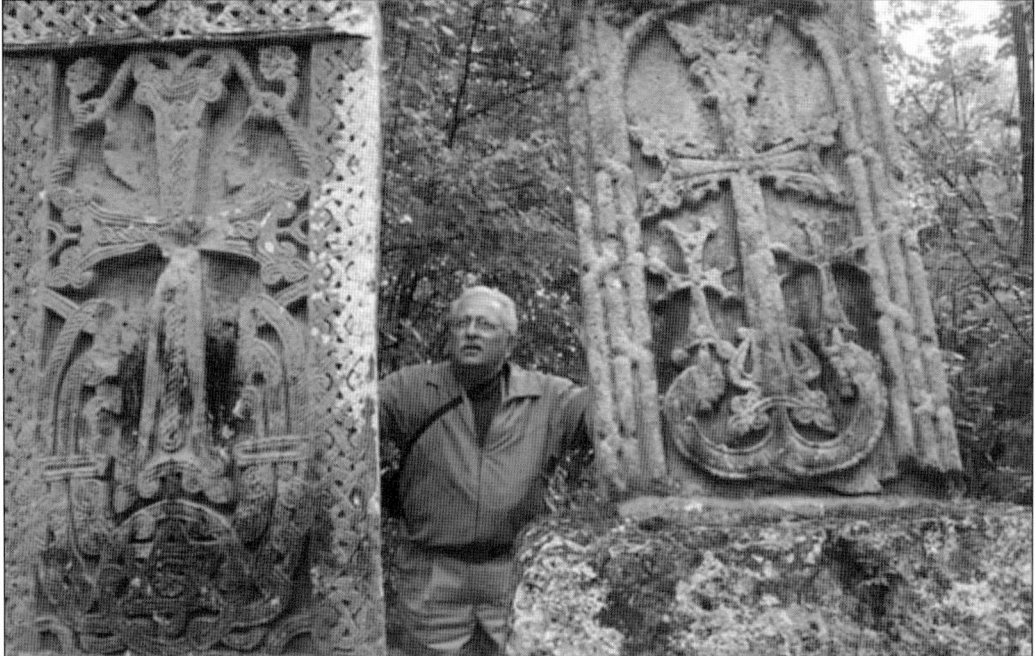

James Apovian Jr. of Haverhill is sandwiched between two *khatchkars* (cross stones) that have endured for centuries after being chiseled by hand. The stones form memorials at churches as vivid reminders of a resilient country that dates back over 3,000 years. Apovian is a descendant of great statesman and writer Khatchatur Apovian and remains active in the St. Gregory Church community in North Andover. (Courtesy of Tom Vartabedian.)

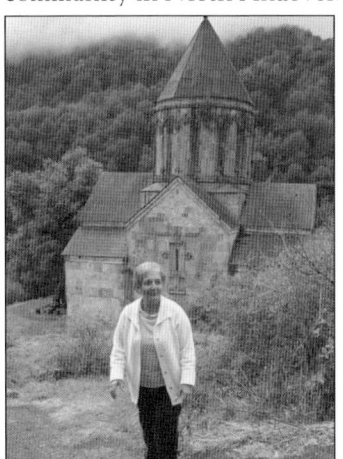 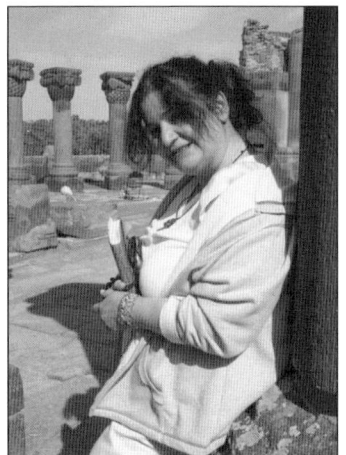 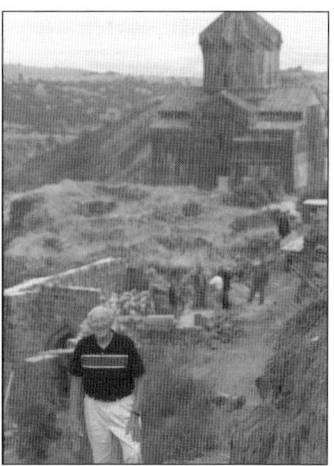

The image at left shows Ann Apovian of Haverhill fulfilling a lifelong dream of visiting the country of her ancestry by touring Haghardzin Monastery in Dilijan, Armenia, in 2006. Apovian is an active member of the St. Gregory Armenian Church community. The center image shows artist Helena Berberian of Andover investigating the ruins of Zvartnots at Armavir during her 2006 trip through Armenia. The circular church dates back to the seventh century and is used for cultural and religious gatherings today. The image at right shows Michael Boloian of Andover meandering through Amberd, an area in Armenia, which housed a seventh-century fortress and residence for kings. Boloian is among the founding members of St. Gregory Church. (All, courtesy of Tom Vartabedian.)

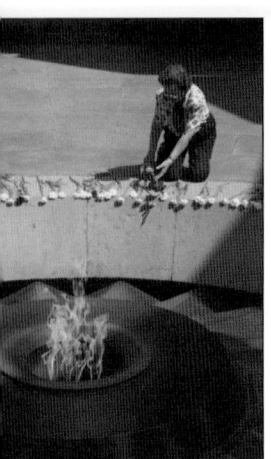 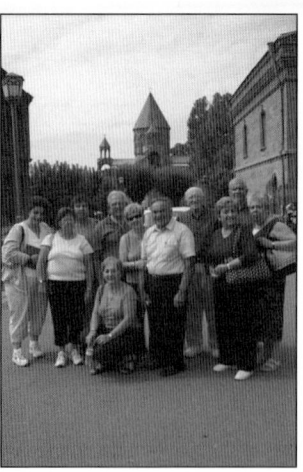 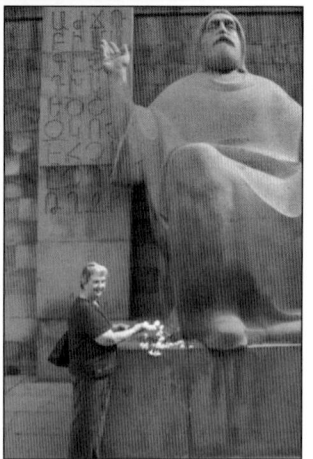 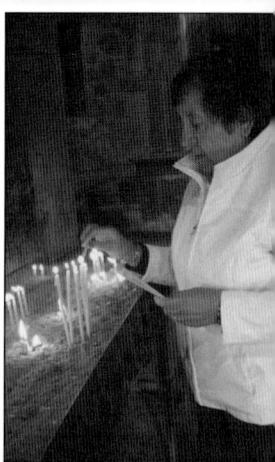

The far left image shows Araxie Kasparian of Haverhill laying flowers at Tsitsernakaberd —the eternal flame—dedicated to the 1.5 million martyrs killed by the Ottoman Empire from 1915 to 1923. Kasparian is an active member of the Hye Pointe Church community. The second-from-left image shows members of the Merrimack Valley Armenian community posing in front of the Holy Church of Etchmiadzin, which was originally built more than 1,500 years ago as a testament to Armenia being the first nation in history to adopt Christianity. The third-from-left image shows Alice Kasparian placing flowers by a statue of Mesrop Mashtots in Yerevan during a Merrimack Valley group trip to Armenia in 2006. The statue is dedicated to the person who invented the Armenian alphabet in AD 404. At one time, Aremenian was considered for use as a universal language because of its simplicity. Kasparian continues to be an active member of the Hye Pointe Church Armenian community. The image at right shows Angele Dulgarian of Chelmsford lighting a candle inside an Armenian church in memory of Armenian victims lost during the genocide. Dulgarian is a 50-year member of the Armenian Relief Society and has made the trip to Armenia over a dozen times, including with her entire family of 19 during a memorable 50th wedding anniversary celebration. "It's the cradle of civilization," she says. Dulgarian is an active member of the St. Gregory Church community. (All, courtesy of Tom Vartabedian.)

One

The Armenian Family Bond

Throughout the history of Armenian civilization, there is nothing more steadfast than the solidarity of an Armenian family. When all is said and done, it is the family that embodies the spirit of a culture and promotes survival. The saying often goes that a wanderer's heart always longs for home. Home is where the breadth of life is enriched, where detours are often met, and where young and old thrive in an arena of love and understanding. When generations act together, they can set one mountain atop another. The intangible, yet thriving, spirit of the Armenian family has kept their nationality from extinction, preserved their language, immortalized their heritage, and prospered their community life. A nation can become fragmented, but a family remains immortal.

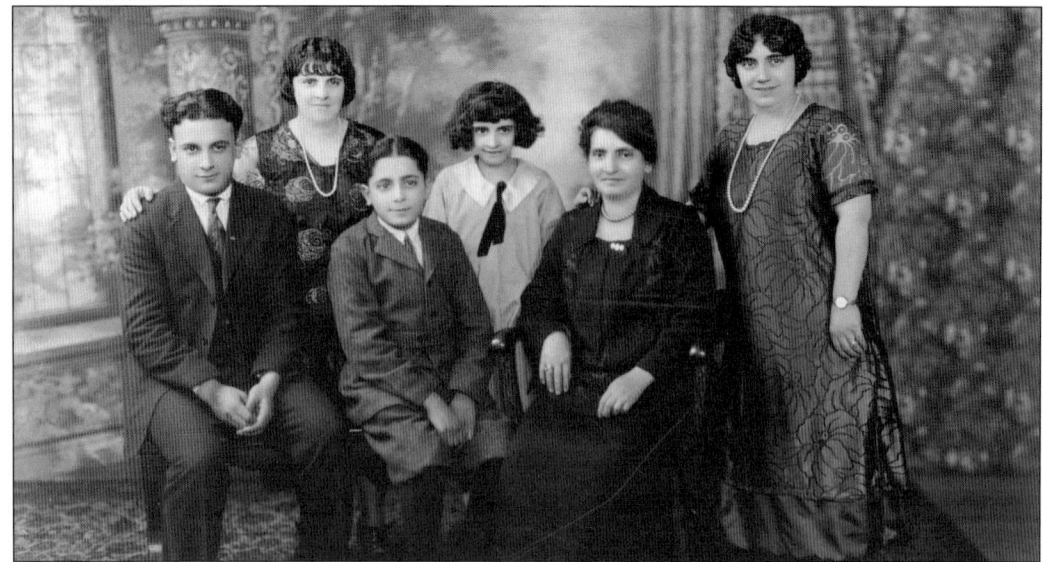

This Kazanjian family photograph taken in 1925 features, from left to right, (seated) John, Carl, and Elizabeth Aroian; (standing) Mary, Virginia (Bedrosian) Tourvanda, and Bessie Gureghian. The Kazanjian family is remembered by Armenians for its dedication and selfless contribution to the construction of Armenian church. The Kazanjians lived in Lowell, where most family members served the church. The family's contribution helped ensure that Armenian religious beliefs and culture are preserved. (Project SAVE Armenian Photograph Archives, courtesy of Mary Ann Kazanjian.)

This Babolian family photograph was taken in Haverhill around 1924. In the center row, Anig, Miriam, and George Babolian were all from Armenia. The family lived on High Street in Haverhill. Miriam died at the age of 111. (Courtesy of Rayissian family.)

Haig Babolian was born in Haverhill and worked in local shoe factories as a leather skiver. Here, a young Haig is shown with his sisters Amy (center) and Maritza (right). Haig married Julia Fitzgerald and had one daughter, Sheila. Maritza later married to Sarkis Gazorian from Worcester, Massachusetts, and the couple had two daughters and a son. One of the daughters, Natalie, married Ara Barmakian, who founded Barmakian Jewelers. (Courtesy of Sheila Babolian.)

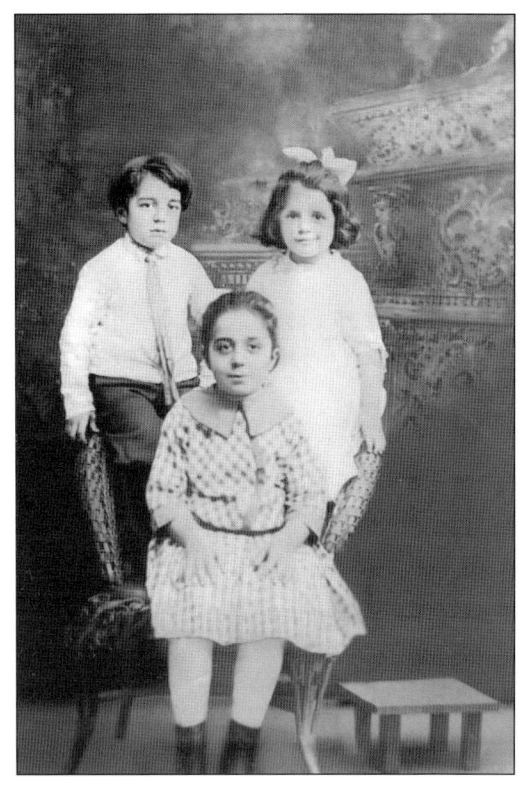

This is a 1946 wedding photograph of Harry and Alice Rayissian. Harry worked as a machinist at Colonial Bow Shop. Alice worked as a secretary at the electric company and the Haverhill Board of Realtors and as a maître d' at the Tap. They had four daughters—Sandra Rayissian Howard, Virginia Rayissian Riley, Linda Rayissian, and Margaret Rayissian Denoncourt. (Courtesy of the Rayissian family.)

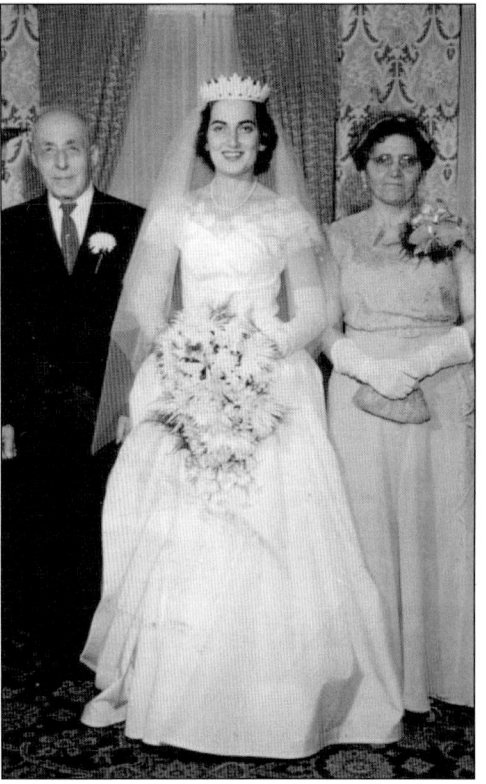

Alexander Terzian (standing at left) is joined by his brother, John Terzian (standing at right), and their parents. Alexander was about 19 when this photograph was taken. He grew up in Keghi, Armenia, and owned a dry goods store. He used the gold he earned from the store to bribe the Turks and get out of Armenia with his wife, Rose, who was 16 when they got married. (Courtesy of Rosalie Sasso.)

Rosalie Ann Terzian was 24 years old when she married Enrico Vincenzo Sasso in 1954. She is pictured with her mother, Rose, and father, Alexander, who both worked in Haverhill shoe factories after the Depression. Alexander had owned Economy Market in Brockton but lost it when the people who owed him on credit could not pay. Born in Brockton, Rosalie went through the Haverhill public school system and attended Northern Essex Community College. She was a committee member of Dollars for Scholars, member of the Women's City Club and Haverhill Arts Society, and a YWCA Tribute to Women organizer and nominee. She taught typing for years in the adult education program at Haverhill High School. (Courtesy of Rosalie Sasso.)

This Dulgarian family photograph was taken in Lowell, Massachusetts, around 1933. From left to right are Lucy Dulgarian (Dumanian), Satenig (Guilbenkian) Dulgarian, John Agop Dulgarian, and Elizabeth "Betty" Shakeh Dulgarian. Satenig was the only survivor of the genocide from the village of Goth in the province of Erzurum. (Courtesy of Steve Dulgarian.)

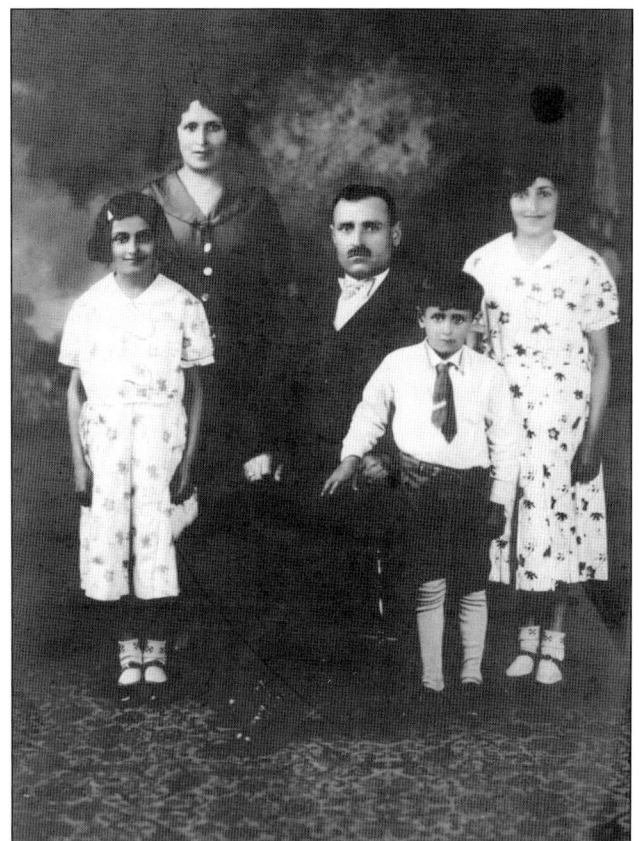

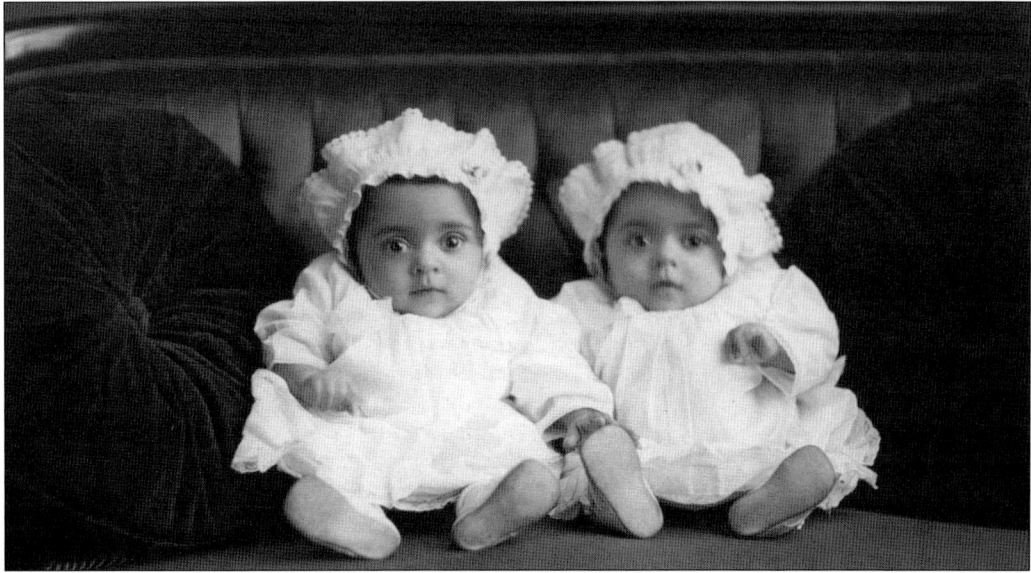

Twin daughters of Myram and Krikor Dulgarian, Vartanoush "Rose" Dulgarian (Martino) and Haiganoush Dulgarian, were born in Lowell before the family moved to Chelmsford. Rose worked at Raytheon for many years. Haiganoush died in 1931 at the age of one and a half. (Project SAVE Armenian Photograph Archives, courtesy of Steve Dulgarian.)

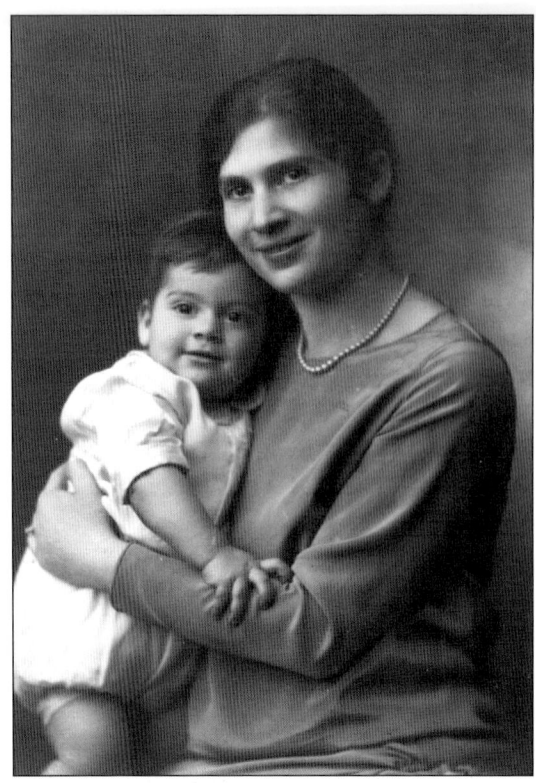

This photograph shows Vartouhie (Stepanian) Movsesian holding her son, Edgar (Vahram) Jr., around 1929. Vartouhie was born in 1905 in Istanbul, Turkey, to Nazareth Stepanian and Pariss (Arakelian) Stepanian. Vartouhie raised a family with her husband, Yeghia Edgar Andon Movsesian, in Haverhill and died in 1992 at the age of 86. Edgar Jr. retired from manufacturing but is still very involved in the Armenian community. (Courtesy of Marsha Kazarosian.)

Edgar (Vahram) Mossman Jr. is photographed with sister Margaret Movsesian (Kazarosian) around 1929. They are the children of Yeghia Edgar Andon Movsesian and Vartouhie (Stepanian) Movsesian. Both children were born in Haverhill. Margaret married attorney Paul Kazarosian, who passed away in 2010. She continues to help out at the law firm Kazarosian, Costella & O'Donnell, LLP, where her daughter and grandsons practice. (Courtesy of Marsha Kazarosian.)

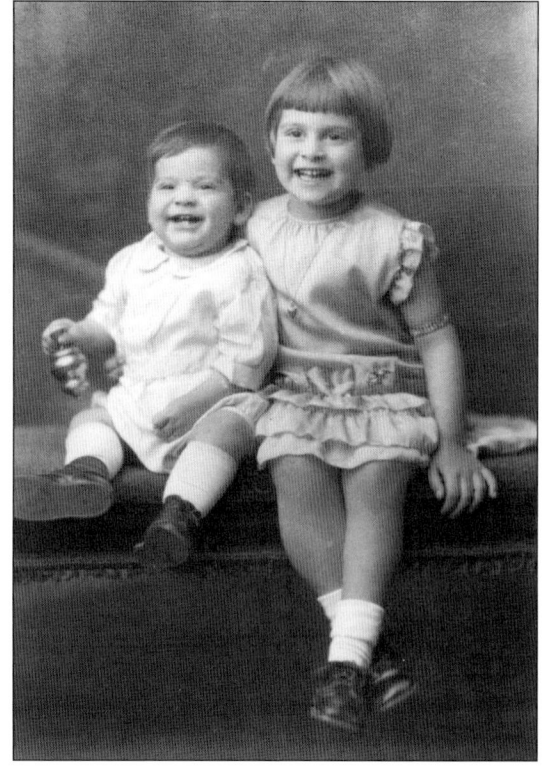

Gadar Kazanjian, shown here, was Azniv Kazanjian's mother. The fish engraving on the arm of the chair signifies that it was hand-carved. Such chairs were common in the 1800s and tended to be expensive for the time. They were used for portraits, such as this, and as heirlooms passed down to future generations. Gadar's daughter Azniv married Haig Kazanjian and immigrated to the United States. (Courtesy of Virginia Chobanian.)

Haig Kazanjian and Azniv Kazanjian (at left) were husband and wife. Yeranig was Azniv's sister. Haig and Azniv immigrated to the United States, where Haig worked for Phillips Shoes in Haverhill until just two years before his death. (Courtesy of Virginia Chobanian.)

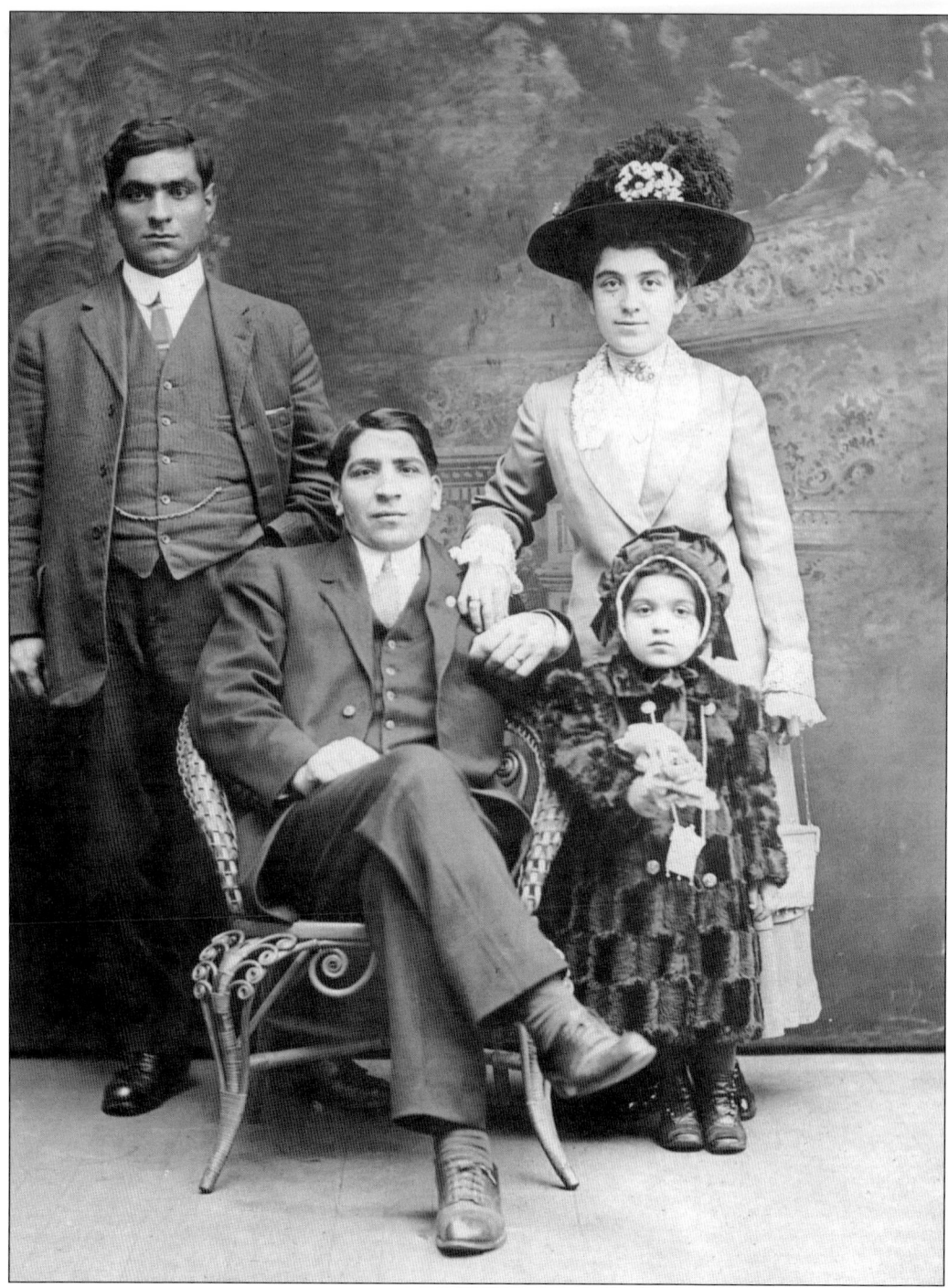

Genia Kazanjian (front right) was born in Chelsea, Massachusetts, to Armenian immigrant parents Haig Kazanjian (seated) and Azniv Kazanjian (back right). As an adult, she worked hard at the shoe factories in Haverhill. Her brother Tony (not pictured) was the manager at the shoe factory. She later married, and her daughter, Virginia Chobanian, along with her family and community, preserves the family legacy. (Courtesy of Virginia Chobanian.)

Martin Khachador Dadekian and his youngest sister, Marguerite Dadekian LoPresti, enjoyed time together at their Webster Street home. Later, Martin quit school to work to help support his four brothers and sisters. Marguerite was fortunate to remain in school and graduate Haverhill High School. While Martin joined the Army and then founded a jewelry store in Haverhill, Marguerite married and moved to Philadelphia. (Courtesy of Maureen Dadekian.)

From left to right are (first row) Zartig, David, and Alton Dadekian; and (second row) Michael, Mary, and Khachador Dadekian, who were born in Armenia. Michael, the elder brother, lies in an unmarked grave in Hilldale Cemetery, because the family could not afford a burial. Mary married the younger brother, Khachador, and had five children. The three children left school to work to help provide for their siblings and parents. (Courtesy of Maureen Dadekian.)

The Kazanjian brothers and Carl Bedrosian are pictured on a farm in New Hampshire in 1928. From left to right are Edward Kazanjian, Avedis Kazanjian, and Bedrosian. The three individuals were very close and lived like one family. Bedrosian, after bonding with the brothers, became part of their family. (Project SAVE Armenian Photograph Archives, courtesy of Mary Ann Kazanjian.)

War veteran Bagdsar Chooljian, son of Hagop Chooljian and Atlas Demirjian, was born on July 15, 1888, in Chunkush, Armenia. In 1966, at the age of 78, Bagdsar died in Essex, Massachusetts. In the image, Bagdsar is in his old age and living in Haverhill, Massachusetts, where he immigrated in 1910 with his wife, Shooshan Lillian. Shooshan died in Haverhill a few years after her husband. (Courtesy of Diane McIntosh.)

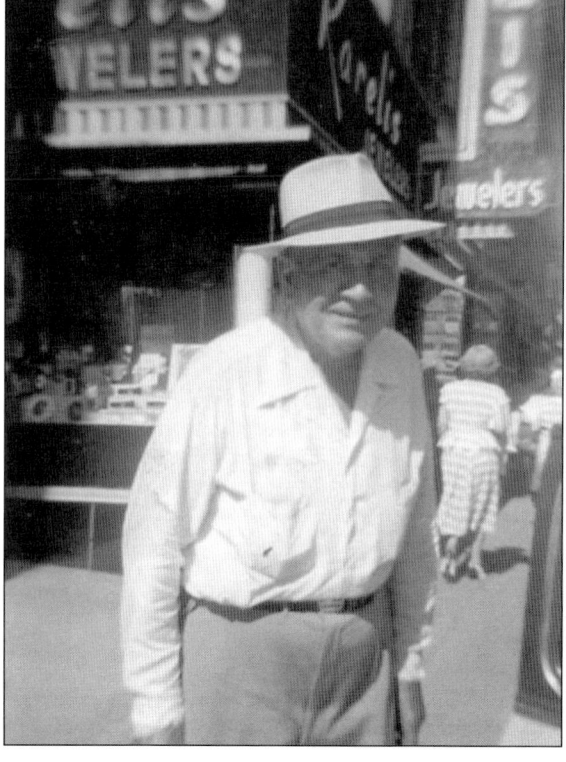

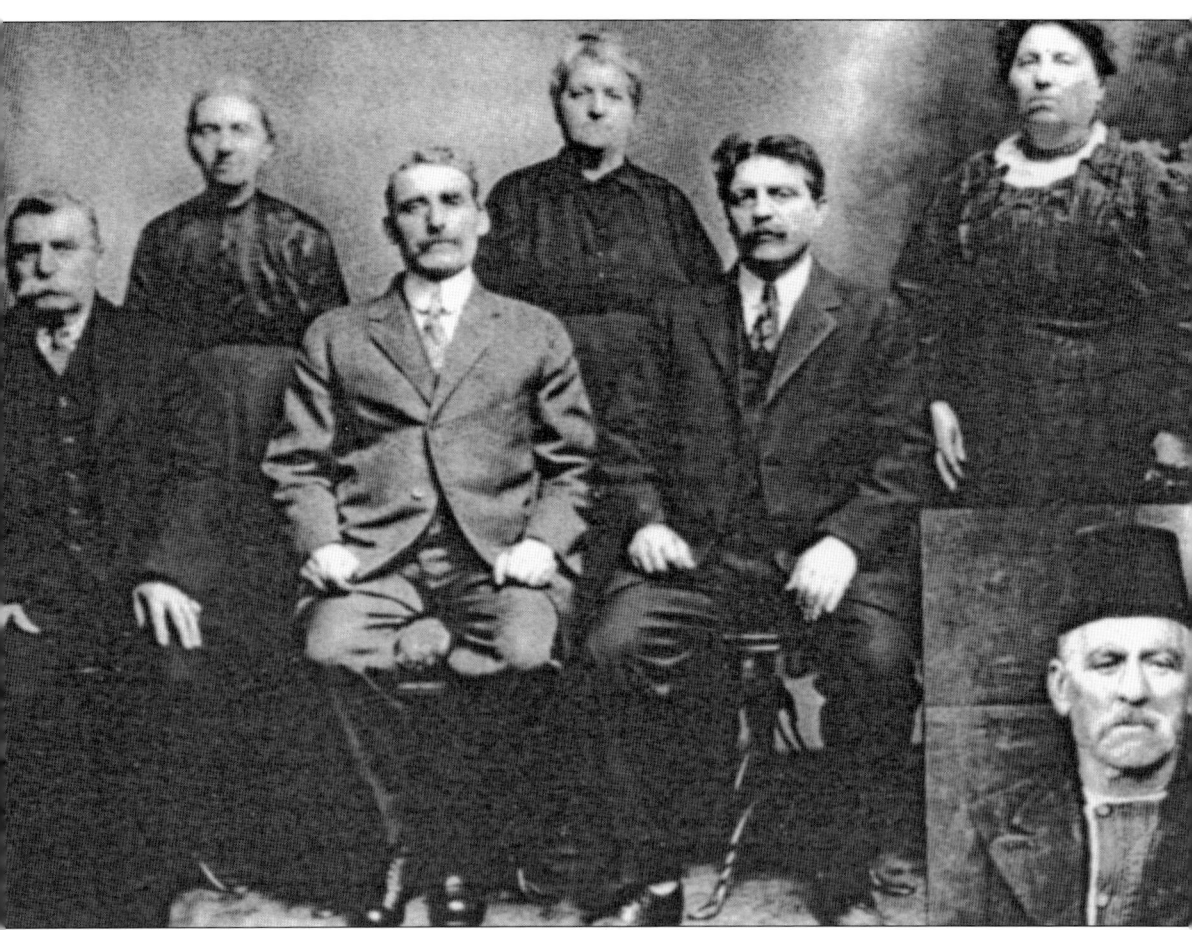

The Krikorian family emigrated from Armenia. All but one of the sons made permanent homes in Newburyport, Massachusetts. Many Armenians in Newburyport found work in shoe shops. Although they did not have an industrial background, they made the most of what the new factories had to offer and adapted to the demands of the occupation. Because many of them worked in these shops, they settled nearby in the middle of town. Only a few of the 60 Armenian families who once lived here remained throughout the 20th century. Some left when the shoe shops closed, and many of the younger generation left after graduating from college. The first generation faced the challenge of adapting to a completely new way of life, from the rural society of Armenia to an industrial community. Through shoe shop and factory labor and frugal living, they were often able to send their children to college. Coming from an environment that respected and honored an education, their children proved to be able students and academic role models. Hard times during the Depression and the upheaval caused by World War II led them to move elsewhere. (Courtesy of Shant Mantarian; inset, courtesy of Joe Callahan, the Newburyport Public Library Archival Center, and the Clipper Heritage Trail.)

Mary Chooljian is pictured with her father, Bagdasar Chooljian, and mother, Shooshan Lilian. Mary was born in 1922 in Haverhill, Massachusetts. She had two brothers, Edward E. and Harry Chooljian. Bagdasar served as a soldier. This photograph was taken in the 1920s, while her father was still working in a shoe shop. (Courtesy of Bill DeZazzo.)

The Amirian family of Haverhill is pictured. From left to right are Ashod Kirkor Amirian; Maritza "Mary" (Movsesian) Amirian, a genocide survivor; Yeranig (Kasanjian) Amirian; Hovsep "Joseph" Amirian; unidentified child; Ashod Nishan Amirian; and Nishan Amirian. Three generations of Amirians have lived at the family home at 45 Wolcott Street in Haverhill. (Courtesy of Sven Amirian.)

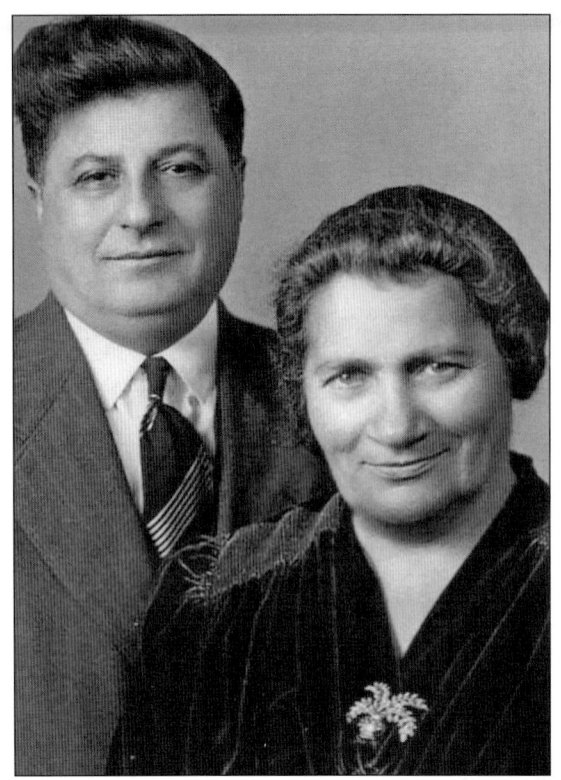

Bagdasar "Charlie" Antaramian (left) was born in 1888 in Karpet, Armenia. He immigrated to the United States from Armenia in 1911. His first wife died giving birth in 1914, and Bagdasar married Esther Sartoian (right) shortly after. Charlie died in 1973 at the age of 85. He worked in the Haverhill shoe shops as a *trear*, ironing leather on shoes. Esther was born around 1891 in Karpet, Armenia. She immigrated to the United States from Armenia in 1914 via Ellis Island. She died in 1975 at the age of 84. Esther worked at home, sewing bows on shoes. (Courtesy of Donna Antaramian.)

Papkin (left) and Johnny Antaramian, sons of Bagdasar and Esther Antaramian, are pictured in 1918. Papkin was born in 1916. He married Corinne Beatrice Goudreault in 1939 and worked at the shoe shops and US post office. He died in 2007 at the age of 91. Papkin and Corinne had two children, Donna and Paul. Johnny was born in 1914 and worked at Haverhill High School as a janitor. He never married and died in 1991. (Courtesy of Donna Antaramian.)

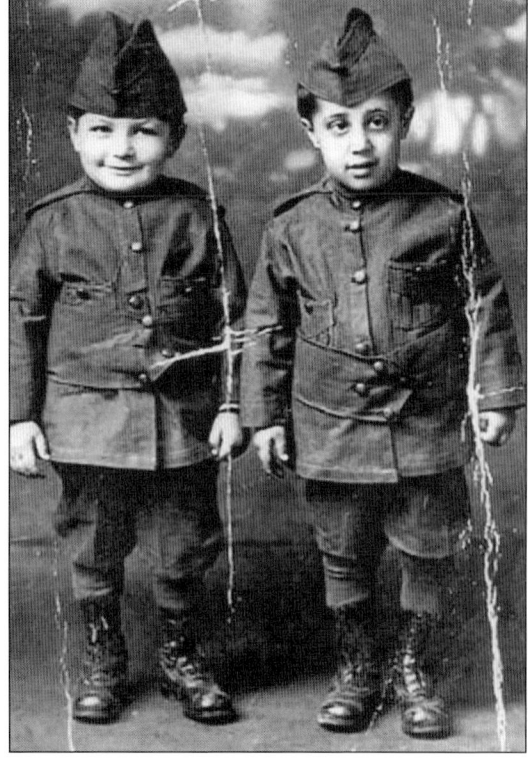

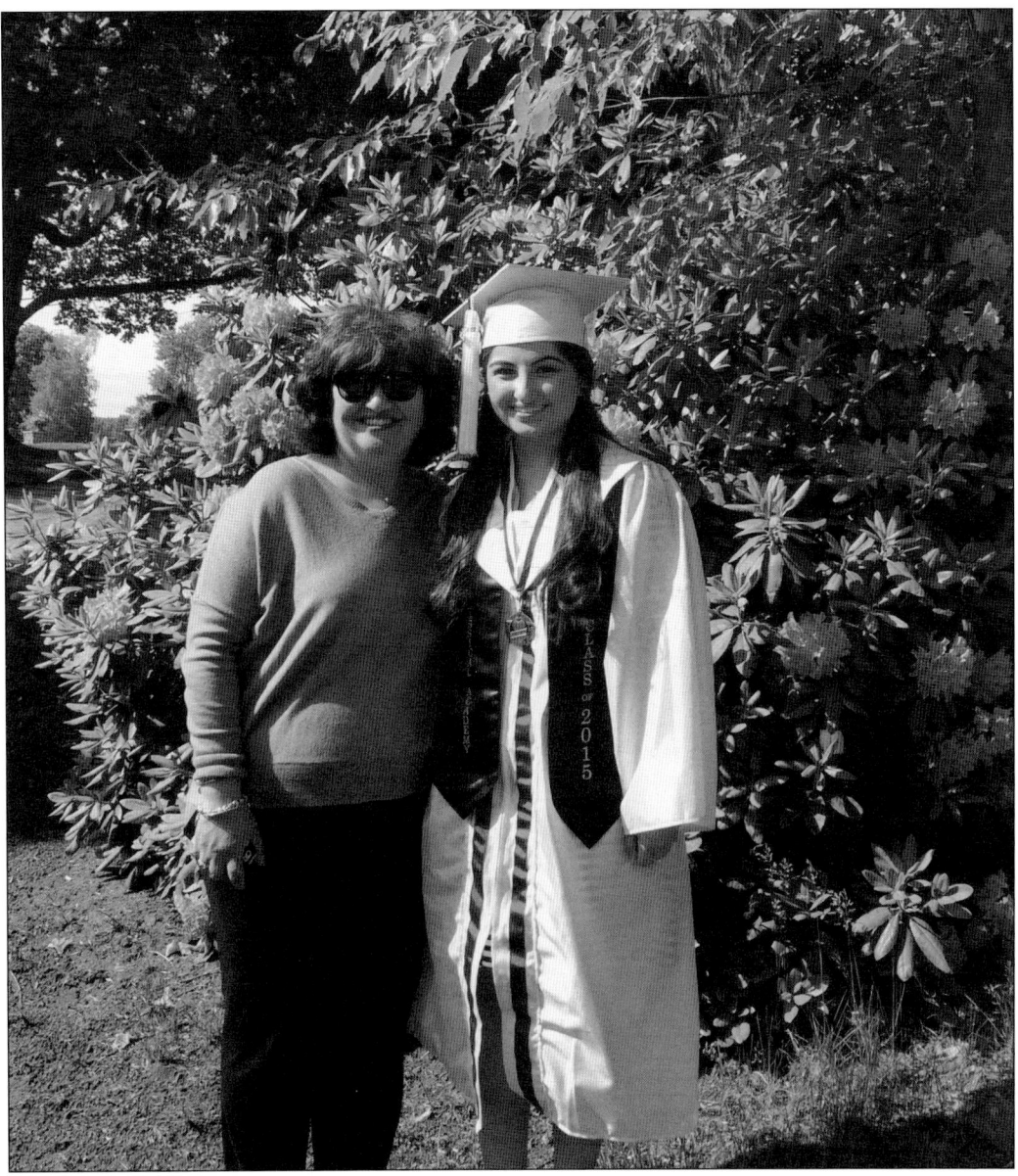

April (DerBoghosian) Kaloostian and her daughter, Emma Kaloostian, are pictured on Emma's graduation day from Haverhill High School, class of 2015. April was the first female senior class president at Haverhill High School, class of 1977. She attended Emmanuel College and New England School of Law and is currently an attorney in Haverhill. Following in her mother's footsteps, Emma was president of the student council her senior year. In addition, she was a member of the Classical Academy. Emma will also be attending Emmanuel College, where she plans to major in history. She is an active member of St. James Armenian Church's Armenian Church Youth Organization of America (ACYOA), and she participated in several events raising awareness for the 2015 centennial of the Armenian Genocide. Their family also includes father and husband, Ken Kaloostian, and son, Harry Kaloostian. April is the daughter of Michael and Mary DerBoghosian of Haverhill. The Kaloostians are all very connected to their culture and proud to be Armenian. (Courtesy of April [DerBoghosian] Kaloostian.)

It was a proud day when brothers Michael and Khachador Dadekian were able to save enough money to bring their nephew Stephan to the United States from Armenia. Families sending for relatives was not uncommon for the time period. Stepan (pronounced Stephan), left, stands by Michael, the elder of the two brothers. The traditional attire includes their surname, in Armenian, sewn on Stephan's coat label. (Courtesy of Maureen Dadekian.)

Two

Preserving Faith

In AD 301, Armenia was the first nation to adopt Christianity as a state religion. Not only that, but according to Genesis, the landing of Noah's Ark on Mount Ararat could, according to some beliefs, mean that Armenia was the birthplace of the human race.

Many alien countries tried to assimilate the Armenians into their own culture but could not succeed. The Persians made every attempt in AD 451 during the Battle of Vartanantz but failed. More recently, the 1915 genocide was a true test of Armenia's courage and tenacity against a Muslim country that was also shunned. The fact that Armenia's churches and memorials lay in ruins throughout Turkey and once-proud sanctuaries have been converted to mosques and museums has not disengaged the Armenian people from their religion but rather solidified it.

In the Merrimack Valley and southern New Hampshire, Armenians attend four churches on any given Sunday. Students attend religious classes, serve as acolytes and attendants, and play active roles in the welfare of their congregations. After more than 1,700 years, Armenia's faith continues to remain untarnished by age.

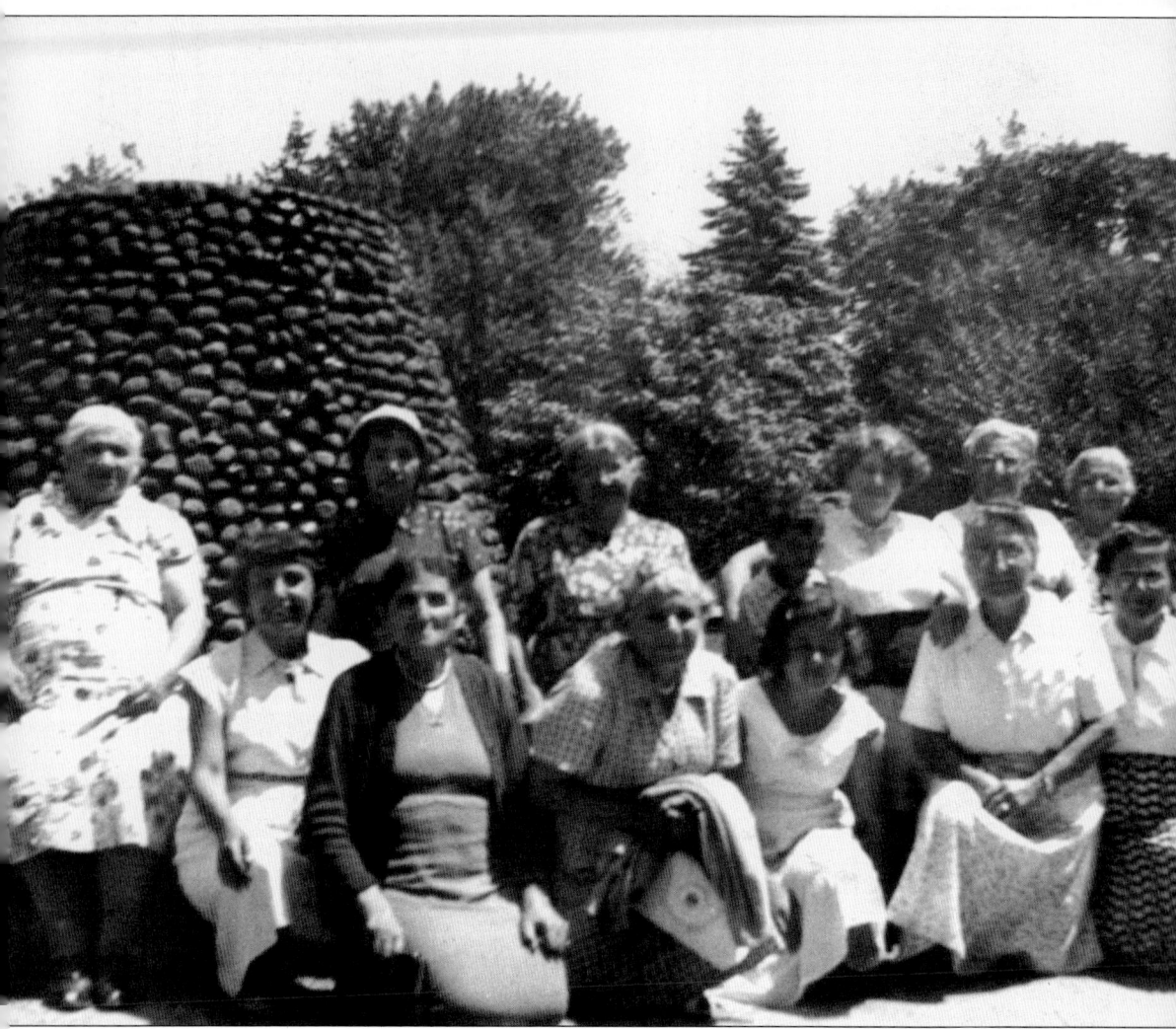

Armenian Protestants of Haverhill was a viable church community located on Washington Street in Haverhill. The church started in the 1930s as the Evangelical Church, which was later changed to Armenian Congregational Church. It continued to attract Armenian Protestants through the 1970s and took pride in its Sunday school, youth group, and family suppers. Among the more prominent members were Rose Kochakian, who taught Sunday school for over 50 years, and Dr. Aram Gulezian, who was one of Rose's first students. Rev. Dr. Youhanna Mugar was a prominent minster over the decades, who traveled from the Watertown area each Sunday to preach to his flock. The photograph shows a women's outing at Canobie Lake Park. (Courtesy of Nancy Vartabedian.)

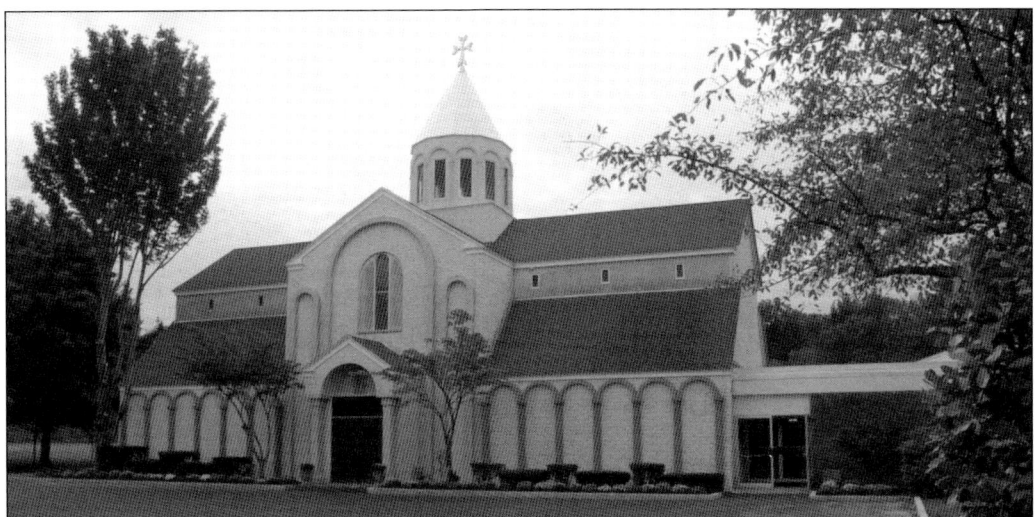

Sts. Vartanantz Aremenian Church holds high its mission of spreading the gospel of Jesus according to the Armenian Apostolic Church. Much dedication is put into following the commands of Jesus to instill a closer relationship to God and form a faith-centered community. The church is under the diocese of the Armenian Apostolic Church of America. (Courtesy of E. Philip Brown.)

Ararat Armenian Congregational Church was constructed for Armenian refugees in the United States after their emigration in the 1800s. This group of Armenians wanted to preserve its culture and religion, and Armenian refugees are said to have sought out a Congregational church in Lawrence as a place to meet and worship together. The Congregational church in Lawrence was established by Rev. Sahag Hovsepian, working together with Armenians. (Project SAVE Armenian Photograph Archives, courtesy of Gladys Mooradian.)

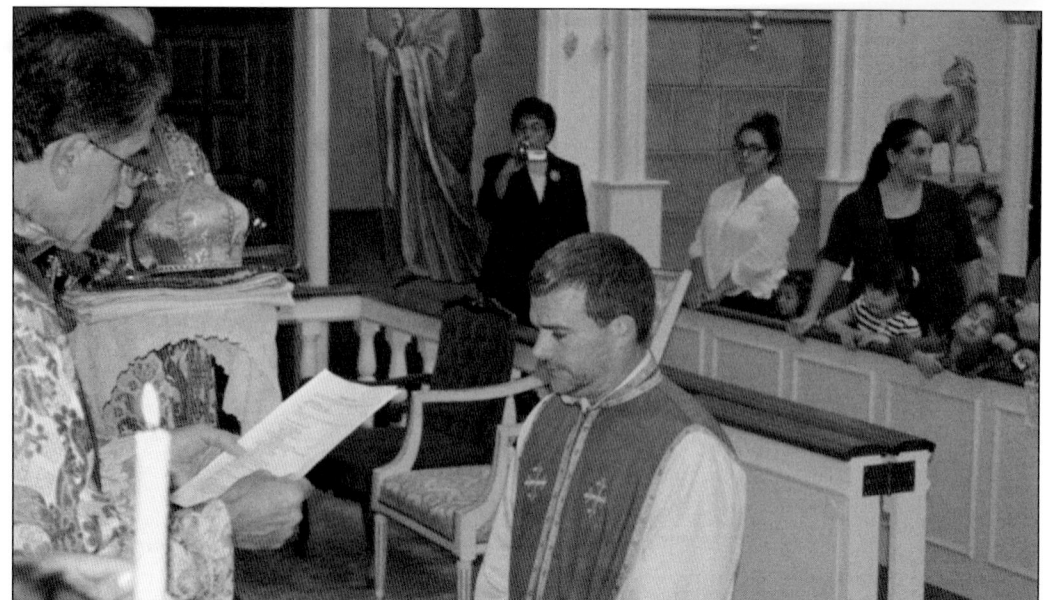

Jeremy Oldham is ordained a subdeacon at Sts. Vartanantz Aremenian Church in Chelmsford, assisted by deacon Ara Jeknavorian. Oldham is among many non-Armenians who have taken a deep-rooted interest in the Armenian church after wedding an ethnic spouse. Olham became attached to the church nearly two decades ago after meeting his Armenian wife Denise Adamian. In his role, Oldham was taught to perform different parts of the Holy Mass, including learning classical Armenian and several other rituals. "For me, it's been a series of invitations, each one carrying me a little further down the Armenian path," he says. (Courtesy of Sts. Vartanantz Armenian Church.)

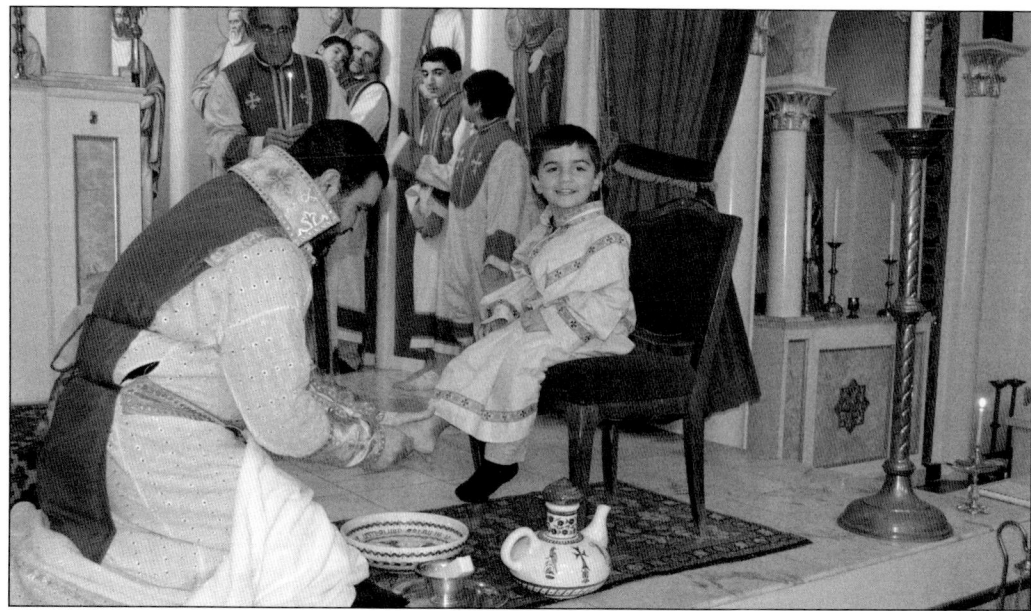

Washing of the Feet on Holy Thursday commemorates how Christ washed the feet of the apostles, setting an example of humility and love. The priest, in turn, washes the feet of 12 church members. Rev. Kachatur Kassablyan is pictured here. (Courtesy of Sts. Vartanantz Armenian Church.)

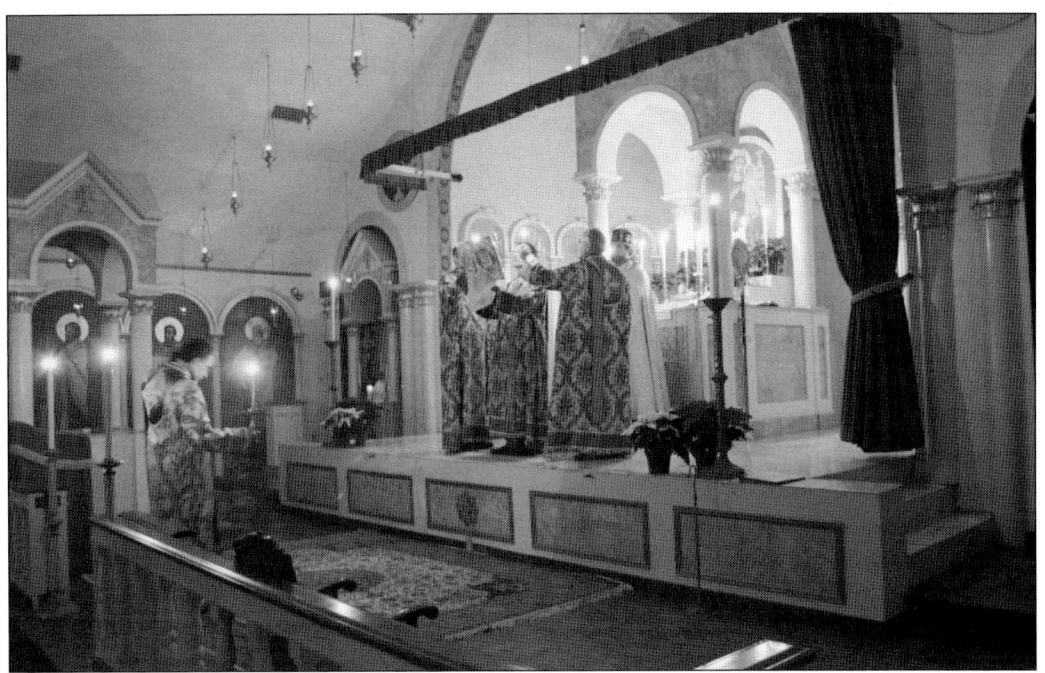

Seen above is the chanting of the Holy Gospel on Easter Eve at Sts. Vartanantz Armenian Church, located in Chelmsford. According to Armenian Apostolic tradition, the celebration of the Divine Liturgy on Easter and Christmas Eves is held by candlelight and referred to as Candlemas. Below, Holy Friday services commemorate the burial of Christ. (Both, courtesy of Sts. Vartanantz Armenian Church.)

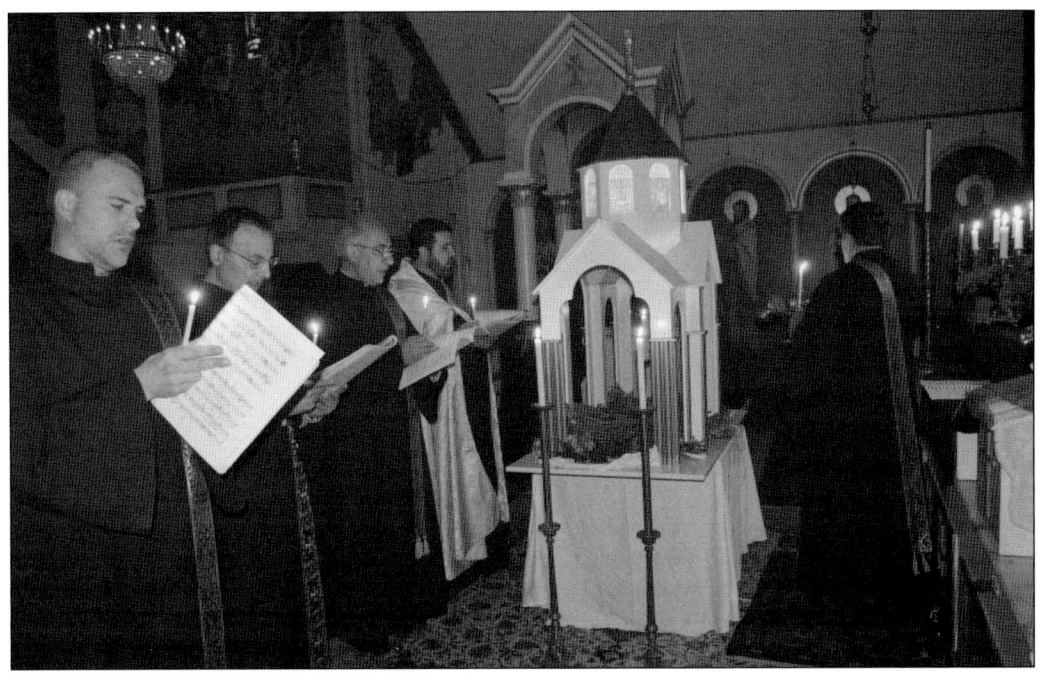

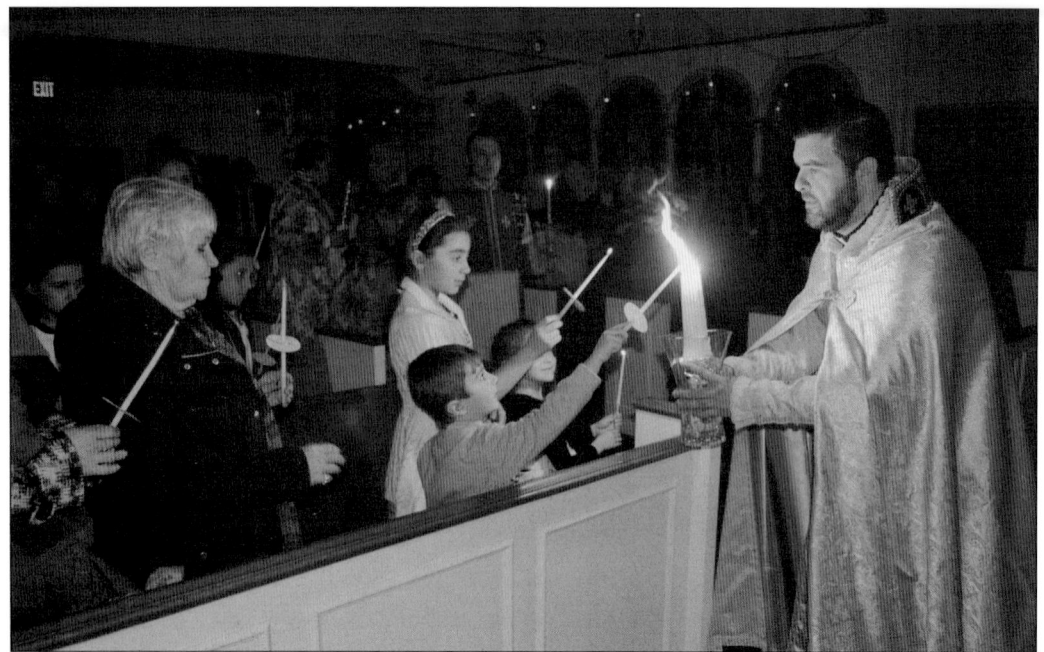

At an Easter Eve service at Sts. Vartanantz Armenian Church, the light of the resurrection is brought from the altar to the faithful by the celebrant, who proclaims, "Christ is risen from the dead." The faithful respond, "Blessed is the resurrection of Christ." (Courtesy of Sts. Vartanantz Armenian Church.)

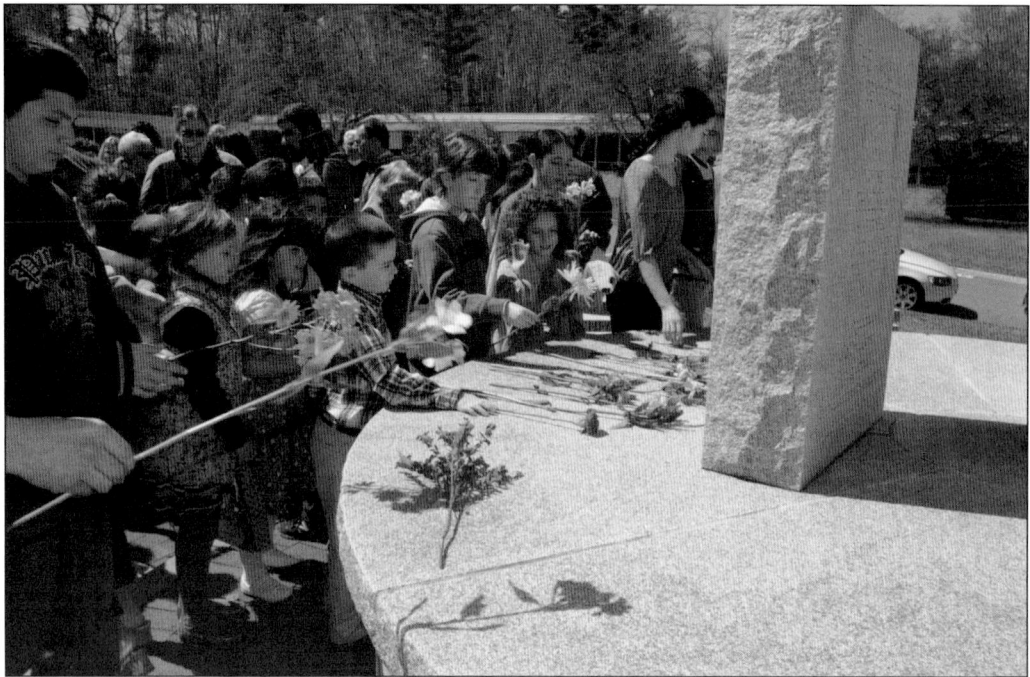

Sunday and Armenian school students of Sts. Vartanantz Armenian Church lay flowers at the church's Armenian Genocide Memorial in remembrance of the 1.5 million Armenians who perished from 1915 to 1923 in Ottoman Turkey. (Courtesy of Sts. Vartanantz Armenian Church.)

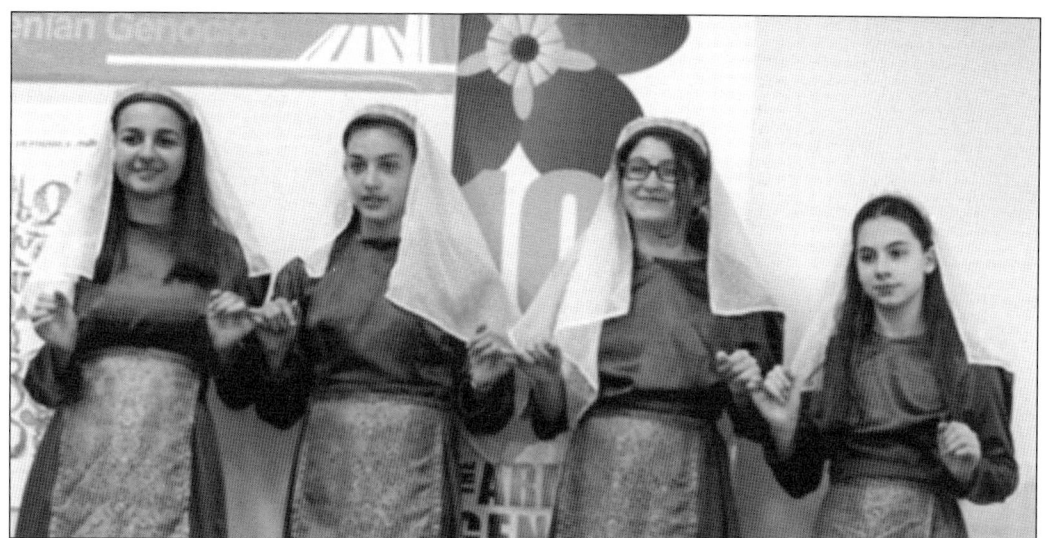

From left to right, Armenian folk dancers Anna Shahtanian, Melanie Almasian, Isabella Kockakian, and Hannah Gaffney were some of the over 35 students performing at St. Gregory Armenian Church's annual Armenian school commencement in North Andover. With dances, historical commemorations, and recitations, the event included students from preschool through 12th-grade programs. The program includes the We Believe curriculum, lessons in the Armenian language acolyte training, choir practice, and lessons to deepen understanding of the Badarak (Holy Mass). The event was held at St. Gregory Armenian Apostolic Church of Merrimack Valley on Main Street, which celebrated its 45th anniversary in 2015. (Courtesy of Tom Vartabedian.)

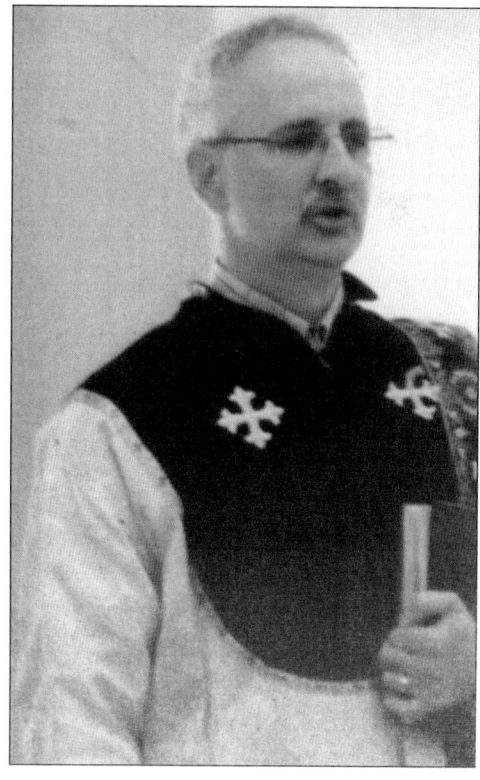

Dr. John Saryan attended the US Air Force Academy. He not only became a two-time gold medalist in tennis in the Armenian Youth Federation Olympics but also a physician. He raised three children, one of whom also became a physician. The elder Dr. Saryan has earned many honors from department chair at Lahey to president of the Scholarship Committee for the Armenian Medical Association and president of the New England Society of Allergy. (Courtesy of Tom Vartabedian.)

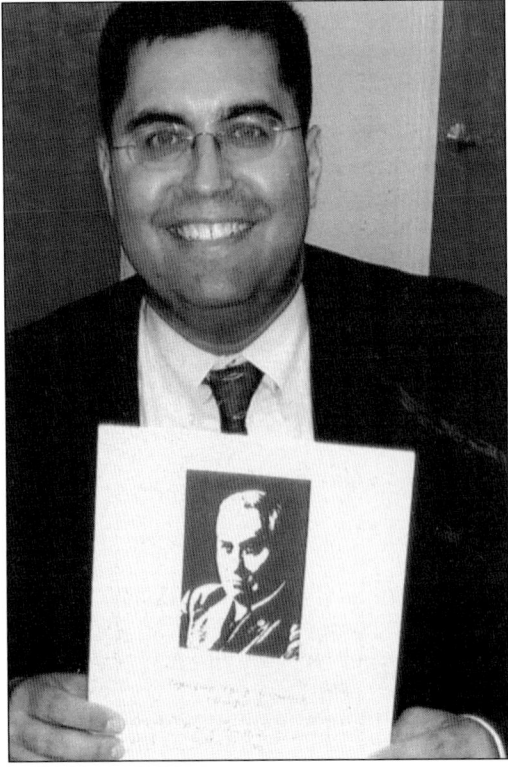

Donabed Kazanjian, who is seen in his horse and carriage in the photograph, was one of the initiators of the Sts. Vartanantz Armenian Church building. The church was constructed with the help of Donabed and a few other Armenians, such as Margos, who took care of the building fund. The original church, consecrated in April 1916, was based in Lowell. It remains a permanent sanctuary, even after the church was moved to Chelmsford. (Project SAVE Armenian Photograph Archives, courtesy of Edward Kazanjian.)

Armenian community activist Dro Kanayan of North Andover admires a photograph of his grandfather of the same name. The elder Dro was an Armenian military commander and politician who served as defense minister of Armenia in 1920 during the country's brief independence. His grandson founded the Armenian Genocide Education Committee of Merrimack Valley, which has brought genocide and human rights education to public schools. (Courtesy of Tom Vartabedian.)

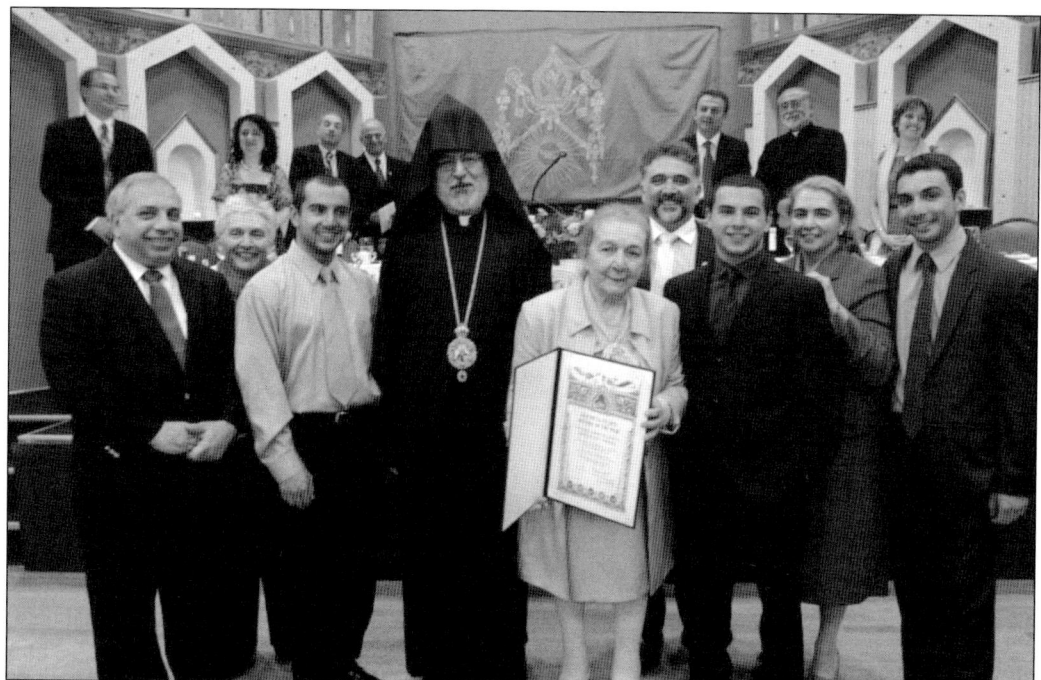

Lucy Daghlian stands with her family at the National Representative Assembly of the Armenian Apostolic Church. She was named Woman of the Year in front of a crowd of over 300. Lucy raised five successful children, supported her husband's pastorship, and stayed by him for the 20 years he spent as a traveling priest. She was active in the church and could always be counted on for her amazing cooking. (Courtesy of Tom Vartabedian.)

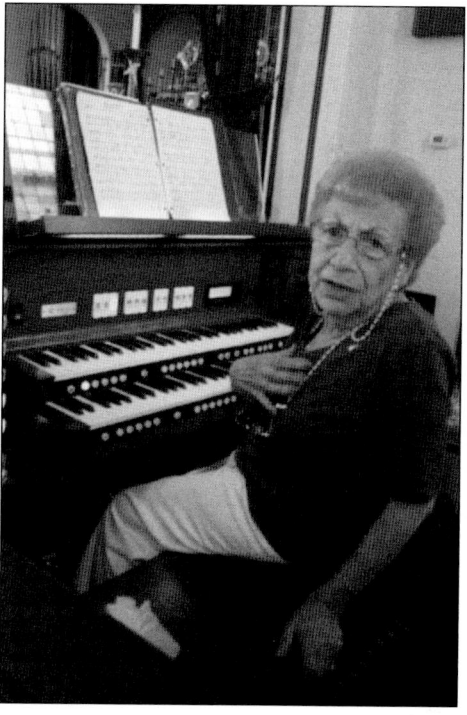

Pictured is octogenarian Sylvia Tavitian, alongside the organ. Sylvia continues to play the organ at the Armenian Church at Hye Pointe in Haverhill, 66 years after first striking the keys. Every time she plays the organ marks "another day in paradise" for Sylvia. (Courtesy of Tom Vartabedian.)

Jennie Vartabedian was one of the Armenian Genocide survivors and always attended the April 24 commemorations with a red carnation in hand. Four days before her death, Jennie said, "Continue being true to your faith and your heritage. But that is not enough. Make sure your children and grandchildren practice their culture and worship God. If we don't have our church and our heritage, we have nothing. The responsibility is in your hands now." This message has now been passed down by her son Tom to his Armenian school students, and they use Jennie's life as an example of resilience. (Courtesy of Tom Vartabedian.)

Fr. Lenny Faris was a young Lebanese man working in his father's grocery story in Lawrence when he walked into the Holy Cross Armenian Church for the first time after being attracted by its music and religious service. He was so enthralled that he joined the choir for what became a 10-year tenure, learning the prayers and rituals as well as how to read and write Armenian. He now pastors St. George Antiochian Orthodox in Lowell, a parish with 150 mostly Middle Eastern families. (Courtesy of Tom Vartabedian.)

Rev. Gomidas Baghsarian, former pastor of St. Gregory Church in North Andover, is joined by Deacon Ara Shrestinian (second from left), during an anniversary celebration at 158 Main Street. The church has served as a centerpiece in North Andover since 1970 and attracts apostolic Armenians throughout the Merrimack Valley and southern New Hampshire. Father Gomidas was a musician and a jeweler before turning to the priesthood, while his wife, Joanna, directed the Sunday school. (Courtesy of Tom Vartabedian.)

His Grace Archbishop Oshagan Choloyan, prelate of the Armenian Apostolic Church of America, Eastern Region, consecrates a memorial at St. Gregory Church in North Andover dedicated to the memory of its late pastor, Rev. Vartan Kassabian. At left is Vartan's son Mgo, serving as a stole bearer. Each year, a benefit is held in Vartan's honor, with proceeds going to the church community. Vartan served the church for 17 years until his 2009 death. (Courtesy of Tom Vartabedian.)

ԵԿԵՂԵՑԱՍԷՐ ՏԻԿՆԱՆՑ ՄԻՈՒԹԻՒՆ
LADIES AID SOCIETY 1966

The 1966 Ladies Aid Society of the Holy Cross Armenian Church celebrated its 50th anniversary September 25th under the leadership of His Grace Bishop Torkom Manoogian. The group printed a pictorial book, *Hishadagaran*, to remember the Ladies Aid Society founders. The 1916 first executive committee included Anoosh Zarifian, Mariam Paroonagian, Loosia Arabian, Isgoohi Azarian, Aghavni Minasian, Heghine Krikorian, and Satenig Boyajian. Within a year, the society grew from 14 original members to 30. Over the past 50 years, the society has worked to develop a school and church and contributed $9,000 towards the construction of the church. Now, it helps maintain the church, sponsors the school, and aids national causes. The society currently includes Armenian ladies from Methuen, Massachusetts; Andover, Massachusetts; Salem, New Hampshire; and Stoneham, Massachusetts. (Courtesy of E. Philip Brown.)

Preparing *choreg* (Armenian sweet rolls) for the annual fair at St. Gregory Church are, from left to right, Rosalie Sasso, Armena Bizios, and Annie Apovian. The annual October event attracts hundreds of visitors who enjoy savory Armenian food and pastries while relishing the camaraderie. These three women belong to the Women's Guild, which sponsors the fair, and have remained friends throughout the decades. (Courtesy of Tom Vartabedian.)

Aram and Alice Der Apkarian admire the new stairway at St. Gregory Church of North Andover. The couple shared 60 wonderful years of matrimony and left behind a legacy of faithfulness that remains indelible throughout the Armenian community. Their children and grandchildren now remain an integral part of the Armenian church community, continuing the work they initiated. (Courtesy of Tom Vartabedian.)

39

An Armenian wedding often turns into an ethnic celebration that involves the traditional church Badarak (Holy Mass) in which crowns are placed on the heads of an engaged couple before the altar of God as prayers are being uttered and a cross is held over their heads uniting the two in sanctity. A wedding reception follows, with Armenian music played by traditional instruments and Armenian line dancing and solos adding to the gaiety. One delightful tradition is that before the bride's veil is placed on her head, she circles the veil over the heads of the single women in her dressing room to bring them good luck in finding a husband. Then a happily married woman will place the veil on the bride's head to bring her marriage luck. This particular wedding party is unidentified. (Courtesy of E. Philip Brown.)

Three

EMPLOYMENT, BUSINESS, AND INDUSTRY

Armenians in every walk of life have carved niches in education, law, journalism, shoe manufacturing, grocery and convenience stores, politics, medicine, and corporate environments, to name a few. In many cases, immigrants were required to attend night school and work productively at menial jobs just to get their children into higher education. They opened tanneries and manned the production lines to earn meager salaries. Many were asked to change their names and give up their heritage as immigrants, but discrimination was no deterrent.

Armenians stuck together and helped each other, regardless of circumstances. A collection of paychecks was often used to bring over other immigrant families and establish a viable presence inside the neighborhoods. At one time, Armenians were represented in most every shoe factory in Haverhill, not to mention the mills of Lawrence and Lowell. Shoe factory work paid the bills and taught human relations, business acumen, and resourcefulness. A typical scene involved Armenian Genocide survivors selling coffee and donuts to Irish and Italian immigrants and hearing how their stories paralleled one another. The Merrimack Valley became their land of opportunity, and they made the most of it.

Lisa Apovian has celebrated her Sontag Prize in Urban Education, given to the educator who best symbolizes the educational welfare of a community, by teaching elementary school in Lawrence, Massachusetts, every day for the past 17 years. At St. Gregory Church, Lisa has taught Sunday school, served as a trustee and member of the Bazaar Committee, chaired the Ladies Guild, and worked bingo events. She also helps with the *Aghavni* newsletter. (Courtesy of Tom Vartabedian.)

Robert Ozoonian graduated from Johnson and Wales College in 1984 with a degree in culinary arts. He has since worked for Caesar's Hotel in Lake Tahoe; corporate hotels, including Marriott, Hilton, and Sheraton; and Odyssey Cruises of Boston. Robert has worked in the industry for 25 years. His latest endeavor is executive chef at Joseph's Trattoria and Bakery. His staff of 20 creates Tuscan Italian cuisine only rivaled by the Italian kitchens of Tuscany themselves. (Courtesy of E. Philip Brown.)

Sebouh Devejian stands with son Anthony in front of the family grocery store at the corner of Washington Street and Washington Avenue near the B&M station. Anthony was manager at Savoy Leather Manufacturing for many years. He was married to Grace (Aramian), and they had three children—Toni Ann, Michael, and Richard. (Courtesy of Toni [Devejian] Bevilacqua.)

Toni (Devejian) Bevilacqua has been the manager of the Classic Couple bridal shop in Haverhill for 30 years. The store is only a couple blocks from her grandfather's grocery store on Washington Street. Toni's husband, Joseph Bevilacqua, is president and CEO of the Merrimack Valley Chamber of Commerce and is on the Haverhill School Committee. The couple has two sons, Michael and Joseph. Toni enjoys gardening, cooking, and spending time with her family. (Courtesy of E. Philip Brown.)

Irene Georgerian is the daughter of Dorothy and George Georgerian. Irene graduated from Haverhill High School in 1978 and was one of the first girls on the track team. She graduated from Northeastern University in 1984 and is currently an actress, filmmaker, and producer in Los Angeles. (Courtesy of Irene Georgerian.)

Pars Nalbandian has been involved with carpets since the early 1800s in Kayseri, Turkey. In 1969, Pars's parents moved to the United States to reunite with his mother's family. His mother began to teach him how to repair carpets in 1975. He worked with his sister-in-law at Brookline Oriental Rugs for five years. In 1983, he established P. Nalbandian Oriental Rugs & Antiques in Andover. (Courtesy of E. Philip Brown.)

Seen in the oil painting pictured here, Paul Kazarosian (1923–2010) was a successful lawyer. His career included conducting volunteer work, owning multiple businesses, establishing the first community medical association in the Merrimack Valley, serving as Haverhill's city solicitor, and winning many cases. He was also one of the founders of the First Bank and Trust in Haverhill and television station WXPO. Additionally, he was a gardener, husband, and devoted father of three. (Courtesy of Kazarosian Law Offices.)

Marsha Kazarosian sits at the Kazarosian Law Offices of Haverhill, next to her son Marc, with associates Linda Little (standing) and Janet Dutcher (seated, right). Marsha has practiced in Haverhill for over three decades, handling everything from personal injury to civil litigation. Recently, the Kazarosians were listed in an issue of *Boston's Top Rated Lawyers*. Marsha is a partner in the firm of Kazarosian Costello & O'Donnell, with offices in Haverhill, Salem, and Lowell, Massachusetts. She has been named by *Massachusetts Super Lawyers Magazine* as one of the top lawyers in Massachusetts each year since 2006 and has been identified as one of the Top 50 Women Lawyers in Massachusetts and New England. In 2006, she was featured in the cover story of *Massachusetts Super Lawyers Magazine* titled "The Power of Marsha Kazarosian," which highlights her career biography and climb to national recognition. (Courtesy of Kazarosian Law Offices.)

Edgar Andon Movsesian is pictured in 1929. The son of Andon and Almas Movsesian, Edgar was born in Kozat, Turkey, in 1896 and moved to Haverhill in 1918. He operated the Dainty Maid Shoe Company and the E&M Fabric Company. Edgar was a member of the Masons, out of the Saggahew Lodge in Haverhill. He passed away in 1973. (Courtesy of Marsha Kazarosian.)

Peter Khanbegian loved flying and took many opportunities to fly when not writing one of his three books. He served in the US Navy in World War II, and prior to starting his fictional trilogy, he was a high-tech writer, avid motorcyclist, model builder, painter, and athlete. Additionally, he helped at his father's dry cleaning store in Lawrence, Massachusetts. (Courtesy of Tom Vartabedian.)

Mr. and Mrs. Ovegen Arakelian settled in West Andover, Massachusetts, in the early 1900s and grew vegetables on 11 acres of land. The vegetables were not enough to carry them through the winter, so their son worked at the blanket factory in Lowell and took odd jobs in town to help support the family. Ovegen was often seen looking out their front bay window. (Courtesy of Library of Congress.)

Pictured clockwise from top left are Amos Asoian, who immigrated to West Andover in the early 1900s and grew vegetables while taking on a job as a truck driver for the Works Progress Administration to support himself and his children; Hazar Loosigian, another Armenian farmer in West Andover, whose son also worked a Works Progress Administration job to supplement their vegetable-based income; Melkon Loosigian, who frequently sat with her husband in their living room, where through the open door, they could see their crops; and Melkon Loosigian, an Armenian vegetable farmer who settled in Andover in Essex County in the early 1900s and, with his wife, tended 14 acres while their son took a job in Arlington Mills in Lawrence to help the family. (All, courtesy of Library of Congress.)

Konjoian's Greenhouses of Andover was established in 1959 by Michael and Vera (Hagopian) Konjoian and has continued to be family-owned-and-operated over the past 50 years. The second generation of Konjoians now manages the business under the supervision of Michael Jr. (pictured). Konjoian's Greenhouses is known for superior customer service and the finest quality and selection of gardening needs. (Courtesy of Michael Konjoian.)

This photograph of Ernest Mazmanian is from the Haverhill High School class of 1922 yearbook. Ernest was the son of Hagop Mazmanian and Nectar (Mirakian) Mazmanian. Nicknamed "Chick," Ernest was on the honor roll at Haverhill High, was awarded a varsity letter in basketball, and sang in the glee club. He worked in the shoe industry in Haverhill. In 1934, he was elected to the General Executive Board of the United Shoe and Leather Workers Union. (Courtesy of Haverhill High School.)

Sarkis and Rita Sarkisian (pictured) own a driving range and hire students to help run the business. The driving range has been active since 1995 and allows the Sarkisians to stay youthful. Both are members of St. Gregory Church in North Andover and relish the opportunity to take a break at their second home on Salisbury Beach. The Sarkisians joined a group of friends for a trip to Armenia in 2006. (Courtesy of Tom Vartabedian.)

Olga Sarkisian began working for the Andover Companies insurance agency in 1954 at age 16. She stayed at the Andover Companies, with the same job description, for over 60 years. Although she learned the computer system, she prefers the Rolodex and pencils. Olga was the last in the company to relinquish her manual typewriter in the early 1990s. She rarely took a sick day, accumulating over 400 sick days in her tenure. Over 350 people attended her retirement party, many with tearful eyes. She continues to live in the same home she was raised in and cared for her mother until her mother passed in 2008. Olga is a founding member of the St. Gregory Armenian Apostolic Church and has maintained the books since 1970, without a single penny unaccounted for. (Courtesy of Tom Vartabedian.)

Olga - the early years

After 60 years of employment, Olga Sarkisian has chosen to retire on July 1, 2014. Please join us on June 6, 2014 at
DiBurro's, 887 Boston Rd, Ward Hill MA 01835 at 4:00 p.m. to celebrate Olga's years of memories.

Pictured are, from left to right, Gavin Jaffarian, Mayor James Fiorentini, Gary Jaffarian, and Mark Jaffarian. The Jaffarians are accepting an award from the Haverhill mayor. Their business, Jaffarian Volvo & Toyota, has been continuously owned by the Jaffarian family for four generations. The family was one of the first to settle in Merrimack Valley and opened Jaffarian Volvo & Toyota in the 1940s. The original owners, Fred and Alice Jaffarian, were active in the community, sponsoring local teams and reaching out to the poor. Brothers Gary, Mark, and Paul Jaffarian took over the business from their father, Richard, and are well known for their charity. Gary's children, including son Gavin, also operate the dealership, and they too are known for their benevolence. When the priest needed a car, they donated one. When asked about charity, Gary noted, "It's the Jaffarian way." (Courtesy of Tom Vartabedian.)

Ashod Niahon Amirian Jr. is the son of Ashod and Mary Amirian. A lifelong resident of Haverhill, Ashod works part-time on town council in Merrimac, but he now spends his winters in Florida, fishing and hunting. After high school in Haverhill, Ashod spent two years in the US Army stationed in Germany. He obtained the rank of captain and met his wife, Lena, during that time, while he was in Sweden. They have been married since 1967, and have two adult children, Sven and Naima. (Courtesy of Sven Amirian.)

George Moonoogian stands next to his wife, Marie, in this 1938 photograph. George was manager and operator of the Haverhill Airport. He was killed when his plane crashed near the airport on July 18, 1941. It was the first fatal airplane accident in Haverhill's history and happened on Haverhill's highest hill. Besides his wife, he left behind a six-month-old son, George E. (Courtesy of Lea Moonoogian Lewkowski.)

George E. Moonoogian receives a congratulatory kiss from his wife, Diane, for winning "Ugliest Teacher Award" at Haverhill High School in 1971, while his daughter Lea Marie looks on. Son George Anthony Moonoogian (1941–2012) was a 1958 graduate of Haverhill High School and received his bachelor's and master's degrees from Salem State College. He and his wife raised two daughters, Lea Lewkowski and Felicia White. He taught at Haverhill High School for 34 years before retiring. During retirement, he and Diane traveled throughout the United States and Europe. In 1998, they fulfilled a lifelong dream by traveling to Australia. (Courtesy of Lea Moonoogian Lewkowski.)

Dorothy and Edward Chooljian were devout in their religion and loved living in the United States. They owned the Fish Tale Diner in Salisbury, where they not only served food but also served up love and stories. Many of their customers were also their dear friends. Edward was referred to as "Fast Eddie" by the regulars. The couple was equally proud of their four amazing daughters and three grandchildren, including Dr. Erica Meisenheimer. (Courtesy of Diane McIntosh.)

Avedis Mellian was born in Armenia, but came to the United States as a youth. His uncles paid his way here. Once in the United States, he married Satenig Hovaginian and worked at Merrimack Valley Motor Inn in North Andover. His son owned the inn, and he worked there almost every day, doing every task imaginable until the day he passed away. (Courtesy of Maureen Dadekian.)

Mary Minasian Dadekian (1920–1997) grew up in Lawrence but fell in love with a soldier. They married, had a daughter, moved to Colorado before divorcing. Mary moved back to Lawrence, remarried, and raised daughter Maureen. She moved to Haverhill, where the family was devoted to the Trinity Episcopal Church and owned a watch repair and jewelry store. Mary was eventually widowed and took a receptionist job. (Courtesy of Maureen Dadekian.)

Armen and Sossy Jeknavorian owned a third-generation locksmith shop in Lowell. The two are known as dedicated entrepreneurs who managed to send three children to college. Armen had two brothers and two sisters. Armen and Sossy are fully dedicated to a number of Armenian causes, assuring people of their heritage continue to prosper. (Courtesy of E. Philip Brown.)

Nancy Movsesian was born in Haverhill and founded the Ideas Associates of Boston, a public relations firm. She spent over 35 years publicizing some of the greatest performers of her generation and promoting venues such as the Charles Street Playhouse. She also organized the Elliot Norton Awards. When not working, she was dedicated to the Armenian Church, frequently assisting with events. She also enjoyed traveling and took every opportunity to visit Armenia. (Courtesy of Tom Vartabedian.)

Highaz "Hy" Der Bogosian was born in Haverhill. His parents, Mahak and Zimrout, were born in Armenia. Hy eventually became president of Kenoza Vending Company of Merrimac. The company began in 1947, when brothers John, Edward, and Hy bought a confectionery store on Kenoza Avenue in Haverhill. Hy and his wife, Florence, had four children—Victoria, Michael, Gregory, and Alexander. Hy is now retired but is very active in the Haverhill Rotary Club. (Courtesy of Der Bogosian family.)

Graduating with a food service management degree from the University of New Hampshire in Durham, Mike Der Bogosian entered his family's vending business and learned it from the ground up. Mike grew up with the family business and was steeped in all aspects of operation—acting as a route driver, route manager, vice president of marketing, and general manager over the years. Now president of the company, Mike lives in Bradford with his wife, Jenn, and kids. (Courtesy of Kenoza Vending.)

Founder and CEO of Year Up, an education program for low-income adults, Gerald Chertavian was recently featured on *60 Minutes*. The Lowell native helps 2,100 adults yearly and has written a best-selling novel, taken a pilgrimage to Armenia, and filmed for multiple shows. Previously, he was head of several multimillion dollar companies and the cofounder of Conduit Communications. He also makes time to be a devoted father of three. (Courtesy of Year Up.)

Four
ATHLETIC ACCOMPLISHMENTS

Whether in football, track, baseball, or hockey, Armenians in Merrimack Valley have distinguished themselves in sports. The Merrimack Valley hosts an Armenian who ran a marathon in every state, a Haverhill High track star who excelled in the Penn Relays and held records for years to come, and a baseball player who won a Cy Young Award as a pitcher for the Atlanta Braves.

The pages of the *Haverhill Gazette*, *Lawrence Eagle-Tribune*, and *Lowell-Sun* list the names of Armenian sports stars, many of whom gained college scholarships for athletic excellence. Several are scholar-athletes, known for their superiority in the classroom as well. Some have taken to the coaching ranks and classrooms as teachers, mentoring a cadre of other athletes as role models. Others served their country in battle and paid the ultimate sacrifice. All of them have answered the call and utilized their talents.

Twenty years ago, Joe Almasian became the first athlete to compete for Armenia in the Olympics. He and his bobsled partner, Kenny Topalian, funded their own expenses and competed in a rented bobsled in Lillehammer, Norway, in 1994. Today, Almasian still enjoys soccer and sports, speaks to a new generation of athletes, and donates time and money to the Armenian Church. An Eagle Scout, he is still is one of the top Olympic scorers in Armenian Youth Federation history. (Courtesy of Joe Almasian.)

The Lowell basketball team was a force in the Armenian Youth Federation during its heyday in the 1980s, winning championships and getting the community involved with athletic spirit. Many of the players excelled in high school and were trained by coach Gary Karibian (far left, second row). The team proceeded to a national championship with a dramatic victory over Philadelphia, during which Merrimack Valley cheerleaders were on hand to encourage the players. (Courtesy of Tom Vartabedian.)

During the 1980s, the Lowell Chapter of the Armenian Youth Federation of America boasted between 30 and 35 members from the Merrimack Valley who competed in the Armenian Youth Federation Olympic Games, coached by Garo Karibian (back left). Many of these athletes excelled in high school and college, going on to nurture children of their own who kept the Armenian Youth Federation tradition intact. Lowell was always a competitive force at these games but more important was the camaraderie and fellowship of members. They distinguished themselves in scholastic endeavors as well as community service. (Courtesy of Tom Vartabedian.)

Edward James Roubian was an award-winning hockey player whose honors included the Art Shaunessy Hockey Award, second-place all-time leading scorer at Waltham High School, Greater Boston Interscholastic Hockey League All-Star, and Beukema Memorial Awards. He graduated the US Military Academy and served five years in the US Army. He then became a quality assurance program manager. He and his wife, Diane, raised two children, Heather and John. (Courtesy of the Armenian Library of America.)

Pictured is the "Marathon Maniac," Michael Goolkasian, who completed a marathon in each of the 50 states and totaled 164 marathons. On top of this achievement, Michael has also completed nine Ironman triathlons. Michael's ultimate goal and ultimate run will be in Istanbul, the place of his grandfather's birth. His motto is "Never give up. You can always walk and get it done." (Courtesy of Tom Vartabedian.)

Barry Chooljian is wrestling coach at Timberlane Regional High School, a small campus in southern New Hampshire with a whopper of a wrestling program. Barry was selected as the National High School Coaching Association's 2010 Wrestling Coach of the Year. A month later, he was accorded similar honors by the National Federation of High School Coaches. Barry presents every opportunity to promote his Armenian heritage, thanks to his dad, who has inculcated the spirit. (Courtesy of Tom Vartabedian.)

Stephen Wayne Bedrosian is pictured in his 1975 Methuen High School yearbook photograph. Stephen is a former major-league baseball player and had a playing career of 14 years with the Atlanta Braves, Philadelphia Phillies, San Francisco Giants, and Minnesota Twins. In 1987, Bedrosian had a record 40 saves and won the National League Cy Young Award. Currently, Stephen has four sons, one of whom was drafted by the Los Angeles Angels in 2010. (Courtesy of Methven High School.)

As a distance runner for Haverhill High School in the late 1970s, Mike Walukevich could be caught by few athletes—especially in the mile, where he distinguished himself at the Penn Relays and recorded times in the 4:15:00 range and lower. He became a three-time All–New England runner. Mike was the coach's dream and continued to distinguish himself in college before turning to law enforcement. Mike is credited with uniting the police department in his city with the Soviet Union. He died tragically at the age of 37, following a Jet Ski accident, after 11 years on the police force. His mother, Marjorie (Takesian) Walukevich, was his greatest fan. (Courtesy of Haverhill High School.)

Karen Guregian has been a member of the *Boston Herald* sports staff since 1984, performing a variety of jobs. Since 2007, she has covered the Patriots full-time, both as the main beat writer and beat columnist. Previously, the Chelmsford native and Northeastern graduate was a longtime Bruins writer and also a key contributor to the paper's Red Sox coverage. A two-time *Boston Magazine* Best of Boston award winner in the outstanding sports reporter category, Karen has covered Super Bowls, World Series, Stanley Cups, NBA Finals, golf and tennis majors, and the Olympics during her *Herald* career. (Courtesy of Karen Guregian.)

Pictured is Mark Kazanjian of the Whirlaway Sports Center. The Whirlaway golf driving range in Methuen, Massachusetts, has been in the Kazanjian family for four generations. His family emigrated from Armenia in the 1800s and founded the Whirlaway Sports Center. He says it all started with his mother, Rose, and her six boys on a potato farm that his father, Joe, worked. Mark's brother George managed the 10-acre golf course, and Mark started working at there after 10th grade. (Courtesy of E. Philip Brown.)

David Kazanjian was named to the Coaches Merrimack Valley Conference All-Star Squad and qualified for the National Junior Olympic Cross Country Championship in 1977. He finished 11th in the Junior Olympic Finals in Washington and second in the AAU Championship in Indiana that year. He was named Most Outstanding Athlete by the WAAA Armenian Olympics committee in 1977. He earned a silver medal at the Louisiana State University Invitational and Massachusetts Indoor State Division B meets and other awards during 1979. Then, due to a back injury in 1979, his college track career ended. He graduated from Southern Illinois University with a degree in business administration. During college, he maintained a 3.36 GPA and was on the dean's list four of eight semesters. Upon graduation, he founded and coached Whirlaway Racing Team, one of New England's top racing/track teams. (Courtesy of David Kazanjian.)

Doug Torosian has been running the America by Bicycle business in Plaistow, New Hampshire, for the past 15 years. Doug and his father, John, shared a common interest in cycling and took some rides before his father died in 1993. The two owned the Bicyclist and Legal Foundation, an organization known for holding charity rides. Doug has made a number of trips, including over a dozen from Maine to Florida. (Courtesy of E. Philip Brown.)

Peter Gulazian graduated from Newburyport High School in 1958 and was a three-sport standout in football, basketball, and baseball. He was the first winner of the Palumbo Award for outstanding play by a lineman in 1957 and also the recipient of the Ryan Cup in 1958. Following his graduation, Gulazian went on to become a social studies teacher at the high school for 38 years and also served as an assistant coach on the baseball and football teams. In 1988, Gulazian helped found the school's golf program, and he served as the team head coach until 2001. He continues to contribute to golf whenever he can. Gulazian's father, Deron, was a member of the first Wall of Fame class all the way back in 1982. (Courtesy of Newburyport High School.)

Five

DEALING WITH THE TRAGEDY OF GENOCIDE

Despite the fact that 100 years have passed since the Armenian nation was brutalized by the Ottoman Turkish government, Armenians today continue to remain steadfast in their culture and heritage with an eye toward the future. They look at the accomplishments made to world civilization over the past century, the communities they helped develop through their resourcefulness, and the spiritual lives they have maintained inside their churches. Although they pay homage to the 1.5 million victims of the genocide each April 24 on Armenian Martyrs' Day, they also look to the survivors who helped plant the seeds inside these communities, cultivating the generations that have followed. Armenians observe this anniversary not because it will bring back the dead and not because their people were dehumanized and violated. They commemorate the genocide because they cling to the hope that, maybe through education and understanding, similar atrocities can be avoided and people everywhere can live together in harmony.

A compelling genocide memorial stands outside Lowell City Hall, erected in 2014 in commemoration of the 1.5 million martyrs who were persecuted at the hands of the Ottoman Empire from 1915 to 1923. It marks the first such monument erected on government soil in the United States. The memorial, titled *Mother's Hands*, was designed by artist Daniel Varoujan Hejinian and initiated by a committee of Greater Lowell Armenian activists. The tribute is paid to the many immigrants who worked the mills and industries throughout the region. (Courtesy of Tom Vartabedian.)

Haig and Azniv Kazanjian loved their adopted country. Both survived the Armenian Genocide and immigrated to the United States. They settled in Haverhill and shared their heritage with the younger generation, including their children. Their wedding photograph is a cherished heirloom. Haig died 11 years after his wife and 12 years after his daughter. He was survived by his eldest child, Antranig Kazanjian, and grandchildren. (Courtesy of Virginia Chobanian.)

In the late 1970s, a contingent from the Merrimack Valley Armenian community—including, from left to right, St. Gregory Armenian Apostolic Church members Sonya Vartabedian from Haverhill; Carol Boloian Minasian and Sylvia Bololan Mahlebjian of Andover; and sisters Grace Chakarian Paltrineri and Janet Chakarian of Chelmsford—attended the Armenian Martyrs' Day march. On that day, two buses filled with Armenians from Merrimack Valley traveled to New York for the march. April 24 was chosen for the international day of remembrance of the 1915 Armenian Genocide, because it was on this day in 1915 that hundreds of Armenian intellectuals were gathered in Constantinople, the Ottoman capital, and massacred. (Courtesy of Tom Vartabedian.)

Koren Tashjian (second row, far left) was the only survivor of the genocide among those in this photograph of the Tashjian family taken in Armenia around 1914. He was born October 18, 1895 in Malatya, Turkey, and immigrated to America, where he enlisted in the Army to fight in World War I. He was badly wounded by mustard gas but saved another soldier's life by carrying him back to Allied lines. Koren was in four field hospitals while recovering from his injuries. He received the Silver Star and Purple Heart, and toured the United States with a Red Cross nurse, selling war bonds. He went back to France, married, and had a son, George Tashjian. They settled in Haverhill, where Koren owned a few unsuccessful restaurants during the Depression—he let too many people eat free. Then, Koren worked in the shoe mills. He passed away on Good Friday, April 1955. (Courtesy of Phil Tashjian.)

Nishan Minasian and Nazley Yeshilian Minasian, who both survived the genocide, stand in their apartment on their 50th wedding anniversary. A Turk helped Nishan escape to the United States, but his sisters stayed behind in Armenia. Nishan changed his name from Der Najarian to Minasian (son of Minas) when he came to America, to honor his father, Minas. Nazley survived the genocide by hiding in a stove when the Turks came into their home. (Courtesy of Maureen Dadekian.)

Sisters Ojen Vartabedian (left) and Vergeen Fundeklian dance at Ojen's 90th birthday party. They were survivors of the 1915 genocide, watching as members of their family were put to death. Ojen escaped by being taken into a Kurdish home. Vergeen, along with their mother, Vartouhi, was taken away for persecution but survived. Ojen and Vergeen reunited with their parents and set up residence in Boston. As teenagers, they operated a confectionery and helped their parents. Then, when Ojen's husband opened a coffee shop, Vergeen helped behind the counter. The sisters shared vacations, and when they were widowed, each drove to visit the other regularly. In a nursing home, they visited each other every week until their deaths. Ojen was the last survivor of the 1915 genocide in Haverhill. They were the sisters of Diyarbakir. (Courtesy of Tom Vartabedian.)

The Kahigian family is pictured here around 1944. From left to right are Twanda (Kahigian) Garabedian (20), Zakar Kahigian (50), John "Chuck" Kahigian (15), Haiganush (Tommasian) Kahigian (55), Markas Kahigian (22), and Sarkis Kahigian (23). Haiganush was married and had two sons in Armenia when the Turks invaded. Her husband at the time was killed, as were her parents, and her sons were taken into France with friends. A Turkish soldier took pity on her and somehow got her onto a passenger ship to America. (Courtesy of Michele Garabedian Stork, EdD.)

Twelve-year-old Noah Aznoian sits next to his great-grandmother, 101-year-old Nellie Nazarian. Nellie is the last survivor of the 1915–1923 Armenian Genocide who lives in Merrimack Valley. Her husband, Stephen, was also a survivor, but he died in 1965. The yearly April 24 commemoration honors both the dead and living and, over the past 25 years, has raised over $70,000 to help worthy causes in Armenia and is attended by approximately 350 guests. (Courtesy of Tom Vartabedian.)

Yeghsapeth "Elizabeth" (Chapoorian) Giragosian of North Andover receives congratulations on her 100th birthday in 2000. Elizabeth arrived in Boston with her sister through the help of an orphanage in France after the two escaped the genocide. Their mother, grandmother, and many friends perished. Elizabeth and her sister joined their father in Boston, where he had been trying to make enough money to bring his family to safety. (Courtesy of Anna Krikorian.)

Haig Kasanjian was a strong man who survived the Armenian Genocide, death of a child, death of a grandchild, and his wife's death. He also survived World War I and World War II. Haig was a talented shoemaker and taught this craft to his son Antranig. Antranig was a shoemaker for a time before becoming a superintendent. Haig was active, even in old age, working until 1959. (Courtesy of Virginia Chobanian.)

Born in Buenos Aires, Argentina, Sara (Mezian) came to the United States with her Armenian parents when she was five. As president and executive director of the oldest art organization in the country, the Lowell Art Association (Whistler House Museum of Art), she brought international recognition to the museum and to the Armenian community through the acquisition of works by the Armenian artist and father of abstract expressionism, Arshile Gorky. Sara has collaborated with some of the top museums in the world, including the Smithsonian in Washington, DC, and the Tate Modern in London. She ran two successful international genocide art exhibitions and symposiums at the museum and was recently named a *Lowell Sun* Salute to Women honoree; the award venerates top women in the Merrimack Valley. She has served in over 20 organizations, including the National Association of Armenian Studies and Research, the Diocese of the Armenian Church of America and the Sts. Vartanantz Armenian Church. Sara holds degrees in education, business, and art history from Indiana University and University of Pittsburgh and has attended the Wharton School of Business and New York University. Sara lives in Massachusetts and has been married to Vasken Michael Bogosian for 38 years. She has two children, Nathan and Vanessa Bogosian, who both live in New York City. She is currently working with the US Department of the Interior and the American embassy in Madrid. (Courtesy of bob@imagekeepers.us.)

Members of Arakadz Lodge No. 35 of the Knights of Vartan are seen here on May 19, 2015. They are, from left to right, past commander Vahan Hanedanian Jr., commander Denis Hamboyan, brother Mike Manoian, chaplain Rev. Stephan Baljian, and sentry Ara Kitabjian. The members pose with a lodge-sponsored New Hampshire resolution recognizing the 1915 Armenian Genocide. Founded in Philadelphia in 1916, the Knights of Vartan has lodges throughout the United States. (Courtesy of Harry Alexanian.)

Pictured here is the 1918 Armenian Red Cross Chapter of Lowell. The organization, later the Armenian Relief Society, was formed to aid survivors of the Turkish massacres. The Armenian Relief Society was established in 1910 in New York City to provide educational and humanitarian assistance to Armenians throughout the world. (Courtesy of Steve Dulgarian.)

Today, projects of the Armenian Relief Society include building, operating, and subsidizing Armenian schools and day care centers, sponsoring orphans in Armenia and Artsakh, operating Armenian one-day schools, providing university and college scholarships, funding the development of Armenian educational curricula and resource materials, and supporting Armenian youth camps. (Above, courtesy of Steve Dulgarian; below, courtesy of the Armenian Library of America.)

Members of the Greater Haverhill Armenian Community gather outside the memorial at Armenian Church at Hye Pointe during a commemoration that included a proclamation and the Armenian flag being raised. The proclamation was issued by Mayor James Fiorentini and read during a televised meeting of the city council. Fr. Vart Gyozalian led a service by the *khatchkar* (memorial) and was joined by two neighboring pastors, Rev. Frank Clarkson of the Universalist Unitarian Church of Haverhill and Rev. Jane Bearden of Trinity Episcopal Church. (Courtesy of Tom Vartabedian.)

Members of the Armenian Church at Hye Ponte were well represented at the Massachusetts State House genocide centennial commemoration in April. From left to right are (first row) Virginia Tavitian, Marilyn Shahian, and Katherine Meranian; (second row) Robert Serabian, Barbara Arthur, and Alice Kasparian. (Courtesy of Tom Vartabedian.)

On May 28, 2015, Chelmsford artist Daniel Varoujan Hejinian (right) was awarded the Medal of Movses Khorenatsi in a presentation by Armenian president Serge Sarkisian. Thousands attended the award ceremony at the Sadarapat Memorial Complex on Armenia's First Republic Day. This is the state's highest honor. It was awarded just a year after Daniel's art exhibit premiered at the National Gallery in Yerevan, reflecting the 100-year anniversary of the Armenian Genocide. (Courtesy of Daniel Hejinian.)

Haverhill High School has increased genocide education in its classes over the years. Advanced Placement students Emma Kaloostian (left) and Sarah Tavitian were among high schoolers present at the ceremony in Yerevan. The Armenian Genocide Education Committee of Merrimack Valley, members of the Greater Haverhill Armenian Community, and others were present for the proclamation and raising of the Armenian flag at the Armenian Church at Hye Point. Several television crews were also present. The program increases genocide awareness among students. (Courtesy of Tom Vartabedian.)

In a phenomenal approach to the Armenian Genocide Centennial, 13 schools called upon the Armenian Genocide Education Committee of Merrimack Valley to offer presentations to students to increase awareness. Participating high schools included Billerica, Tewksbury, Lowell, Chelmsford, Tyngsboro, Lawrence, Haverhill, Andover, and North Reading. The Genocide Education Committee was formed seven years ago in response to the State Department's ordinance to increase genocide education in public schools. Since then, members have taken the initiative to contact schools and present discussions. In each case, the results have proven beneficial. (Courtesy of Tom Vartabedian.)

An Armenian flag was donated to Andover High School by students working closely with the Armenian Genocide Education Committee of Merrimack Valley. (Courtesy of Tom Vartabedian.)

Above, Tamar Almasian does a traditional Armenian folk dance with the Siroon Dance Ensemble during a church picnic in North Andover. Below, a number of Merrimack Valley children wishing to cultivate their heritage and culture take to the dance floor, where they are outfitted in Armenian costumes and taught the steps of their ancestors dating 3,000 years back in time. Costume designs are further influenced by religious customs, family methods, and practicality. (Both, courtesy of Tom Vartabedian.)

Six

CELEBRATING ARMENIAN CULTURE AND TRADITION

Descended from a 3,000-year-old civilization, Armenians in Merrimack Valley continue to cherish their unique artistic traditions with pride. Aspects of daily life are expressed in the arts and sciences, photography, ethnic cuisine, literature, music, dance, performing arts, film production, and more. Architecture is among the most prominent in this region, especially with the erection of Sts. Vartanantz Armenian Church in Chelmsford, which is a replica of the old Cathedral of Ani in Armenia, a domed cruciform church built in AD 1001 and considered a masterpiece.

Armenian art takes the form of needlework, embellishments, designs, oral recitations, poetic verse, and school plays. The contributions made especially to music have been notable, not to mention the written and published works, church embellishments, and sculptures. And no local artist has contributed more to culture in Merrimack Valley than Daniel Varoujan Hejinian of Chelmsford, who has adorned churches with his delicate strokes, designed the genocide memorial in Lowell, and erected billboards over the past 20 years commemorating the genocide. Like its language, culture has remained the Armenian lifeline.

Gary Jaffarian, president of Jaffarian Volvo & Toyota in Haverhill, donated his family photographs to the Project SAVE Armenian Photograph Archives. He is shown meeting with executive director Ruth Thomasian after losing both his parents. The Jaffarians were among the first settlers in Haverhill, immigrating before the 1900s. They established a car dealership that today spans four generations. The family is also known for its extreme philanthropy and community spirit, both inside and outside the ethnic mainstream. (Courtesy of Tom Vartabedian.)

Johnny Berberian plays the oud with his ensemble at the Lowell Folk Festival. Regarded as one of the country's best musicians, Berberian has been entertaining Merrimack Valley Armenians for six decades, teaching youths and engaging himself in numerous social and religious interludes. Over the years, many prominent Armenian musicians have exercised their talents in the Merrimack Valley. Through song and dance, these musicians cultivate old standards and enliven history. (Courtesy of Tom Vartabedian.)

Megan Ahigian (left) and organizer Sossy Jeknavorian (right) serve food at the Lowell Folk Festival for the Armenian Relief Society. The Armenian Relief Society has been promoting ethnic cuisine at the festival for over 25 years, using the profits to maintain its community center on Liberty Street and assist charities worldwide. School and camp scholarships are only part of the outreach mission, which has assisted Armenian education and families in need since its inception in 1910. (Courtesy of Tom Vartabedian.)

Members of the first Lowell Armenian Revolutionary Committee are pictured during the World War I era. Children and grandchildren have carried the organization through the years to a stature of nobility and homage in the Armenian community. Many worked as laborers, providing for their families and instilling the culture and heritage to succeeding generations with pride. It was important that wedlock remain in the Armenian tradition and that the language stood firm in their new land. (Courtesy of Steve Dulgarian.)

Photographer Sona Dulgarian Gevorkian displays her photographs of Armenia at a Bedford Public Library exhibit. Gevorkian is chairwoman of the Lowell "Lousintak" Chapter of the Armenian Relief Society and has made repeated trips to Armenia, either with her family or on relief missions to assist villages and towns in need. Like many others, she received her early enthusiasm through the Armenian Youth Federation of Lowell, playing an active role in the welfare of others. She has always been passionate about photography. (Courtesy of Tom Vartabedian.)

Rose Babaian preserves the Armenian heritage through scrapbooking. Her scrapbook includes over 400 pages, featuring multiple generations, and recently gained the attention of musician John Arzigian. He traveled over 100 miles to see the scrapbook, which to his surprise contains a story of his uncle. Although she has received accolades for the scrapbook, her joy is not in the accolades but in the pride of seeing Armenians succeed. Since her teens, she has cut out articles about Armenians. (Courtesy of John Arzigian.)

Fondly called "Papa" by children, Armenian prospector Rafik Papalian stakes claims in Ghana. Even though he is in West Africa, he remains close to his Armenian roots and developed an Armenian community there, where he and others get together to speak in their native language and enjoy Armenian cuisine. When not working, Papalian donates time and money to orphanages, Armenian churches, and schools. (Courtesy of Tom Vartabedian.)

Alton Dadekian was a great actress, singer, and entertainer who sometimes dressed as a hobo, performing for neighborhood children. One of her performance venues was the Swasey School and Field area shown in this photograph. Among the children watching is Martin Dadekian (fourth from left), who is gazing lovingly at her. He also was adept at making his own fun. In his later years, he entertained his children until his 1978 death. (Courtesy of Maureen Dadekian.)

Pictured here is the Armenian float in the 1913 Fourth of July Parade in Newburyport, Massachusetts. Newburyport is a small historic seaport town north of Boston that delights in its Independence Day celebrations. Early in the 20th century, there was a relatively large Armenian presence working in the town's many shoe factories. (Project SAVE Armenian Photograph Archives, courtesy of Hagop Bedrosian.)

Brothers Aram & Armen Jeknavorian man the grill at the Lowell Folk Festival, preparing the popular losh kebab (Armenian-style hamburgers). Both men have remained as activists throughout the Armenian community along with other members of their family. The festival draws hundreds of thousands each July. The booth remains a popular attraction with its Armenian foods and pastries, thanks to a cadre of volunteers who pitch in, regardless of generation. (Courtesy of Tom Vartabedian.)

Milka Jeknavorian (left), Denise Oldham (center), and Amy Vartoukian are preparing the losh kebab mix for the Sts. Vartanantz annual church bazaar. The annual bazaar features delicious Armenian foods and pastries, jewelry, holiday gifts, a country store, children's activities, raffles, a silent auction, and much more. (Courtesy of Ara Jeknavorian.)

Born in Lawrence, Massachusetts, in 1975, Holly Bedrosian is a self-taught artist who focuses on portraiture and figurative fine art. Her father, Peter Bedrosian, grew up in Methuen, Massachusetts, and his family is from the Habousi Armenian village. Holly's work has been exhibited at numerous national and international exhibitions, and included in various publications. Shown here is her colored-pencil self-portrait, *A Second Cup*. (Courtesy of Holly Bedrosian.)

Daniel Peter Bedrosian was born in Lawrence, Massachusetts, the third child of concert-level classical pianists Peter and Jeanne Bedrosian. Danny was eventually brought in as a full-time musician in the George Clinton and Parliament-Funkadelic collective, and has played all over North America, the Caribbean, Europe, Australia, and New Zealand with P-Funk. He is now featured on a handful of live P-Funk releases, P-Funk albums, and spin-off albums. (Courtesy of Danny Bedrosian.)

Martin Barooshian is internationally known for his artwork. He is similarly known for his generosity. He donated a new artwork he created just for the 100-year commemoration, "The Armenian Nation Lives On," as a poster to the community. The poster image is free for anyone to use and is titled *Armenian Sphinx*. The Surrealist has been painting worldwide for over 55 years but never loses touch with his roots. (Courtesy of Martin Barooshian.)

John Arzigian has a generous heart, regardless of whether he is cleaning headstones for charity or singing in front of hundreds. A jack-of-all-trades, he retired from the computer industry, performed and recorded with the Hye Echoes, formed a volunteer group to pressure-wash headstones in many cemeteries, and raised funds for the St. Gregory Apostolic Church. A group Arzigian founded, Armenian Friends of America, raises money for local Armenian churches. (Courtesy of Tom Vartabedian.)

Sonya Vartabedian Sico (center, in white dress) marches in a parade during a cultural observance of different ethnic groups in Haverhill. Here, she is shown representing her Armenian heritage, joined by members of the Greek community. Armenian schoolchildren have taken pride in their ethnicity while attending Armenian school locally and engaging in various activities that promote their heritage. Sonya is currently features editor of the *Eagle-Tribune* and editor of the *Andovers Magazine*. Her local journalism career, which has surpassed 25 years, includes stints at the *Haverhill Gazette* and *Newburyport News*. (Courtesy of Tom Vartabedian.)

Oskian and Mary Dulgarian are pictured with children Daren and Nairi at the Amberd Fortress. Amberd (Fortress in the Clouds) is a seventh-century site located 7,500 feet above sea level on the slopes of Mount Aragats at the confluence of the Arkashen and Amberd Rivers in the province of Aragatsotn, Armenia. (Courtesy of Steve Dulgarian.)

Steve and Angele Dulgarian are pictured with their nine grandchildren at Noravank (New Monastery) in Armenia. The Dulgarian family has made 15 trips to Armenia over the years. Located 75 miles from Yerevan in a narrow gorge made by the Amaghu River, Noravank is a 13th-century Armenian monastery near the city of Yeghegnadzor, Armenia. (Courtesy of Steve Dulgarian.)

Children of Armenian descent in Merrimack Valley preside over a flag-raising ceremony at Lowell City Hall, a tradition that has manifested itself over the past 50 years in observance of Armenian Martyrs' Day. A compelling memorial currently graces the site in tribute to the fallen martyrs. (Courtesy of Tom Vartabedian.)

Seven
Dedication to Community

The spirit of volunteerism and patronage has been prevalent over the years in Merrimack Valley. Armenians have volunteered their time to the local hospital, library, food banks, community centers, and anywhere else that might warrant assistance. Many are retirees who worked long and distinguished careers and are now looking to give something back to their cities and towns. However, these activists can be found in almost every walk of life, and include coaching assistants, tutors, nursing home aides, and chamber of commerce volunteers. These unsung heroes keep the organizational ship afloat. Other Armenians take pride in sharing their stories and photographs with audiences, encouraging others to visit their ancestral land. Some work as Armenian and Sunday school teachers, and others attend booths at fairs and bazaars. The Lowell Folk Festival has hosted a food tent sponsored by the Armenian Relief Society for the past 25 years. The tradition of community service abounds.

In the early 1890s, an Armenian family fled Turkish oppression, boarded a French freighter, and arrived in Marseilles, France. With their life savings spent, the family appealed to the Salvation Army, which contacted its American branch to find a sponsor for the family. In 1894, the family landed in New York, traveled northeast, and settled in Newburyport. The father, Donabed Arakelian, worked in a shoe factory and later opened a fruit business. His young son, Nicholas, left grammar school to find a job to help his family. Nicholas began working at *Fowle's News* and spent the rest of his life there, becoming a manager and later an owner. When Hannah Fowle retired in 1916, she gave half the company to Nicholas, and he purchased the remaining half in 1920. In 1980, Nicholas established the Mary Alice Arakelian Foundation in memory of his beloved wife, who died in 1965. Mary Alice was hired as his first bookkeeper when federal income tax was created. The foundation continues to generously support community institutions and nonprofit organizations. (Courtesy of Joe Callahan, the Newburyport Public Library Archival Center, and the Clipper Heritage Trail.)

Known around town as the "Mad Hatter," Susan Kulungian appears as a chef with one of her cancer hats one day. The next, she may have a pirate hat. Susan is a stay-at-home mom of two who keeps a positive attitude and brings smiles to others as she fights cancer. She maintains a blog to help others with cancer. Despite the toll of treatment, she still contributes heavily to her Armenian church community. (Courtesy of Tom Vartabedian.)

Sheila Babolian worked for 36 years at Western Electric in North Andover as a tester. She has spent the last 30 years volunteering for the Haverhill Council on Aging. Sheila is a familiar face at the Haverhill Citizens Center, where she can be found assisting with elderly activities and community meals. (Courtesy of E. Philip Brown.)

The Armenian National Committee of Merrimack Valley has been a catalyst in connecting with local and national politicians and briefing them on national and international conditions. Among those paying heed was Congressman James Michael Shannon (center), a Democratic politician from Methuen, Massachusetts. Here, Armenian National Committee activists Steve Dulgarian (left) and Ara Jeknavorian (right) meet with the congressman. Shannon served from 1979 to 1985 and later became Massachusetts attorney general. During his years in public office, he was always a good friend of the Armenian people. (Courtesy of Tom Vartabedian.)

Albert (Shavarsh) Movsesian addresses a class of high school students on the Armenian Genocide as a member of the Armenian Genocide Education Committee of Merrimack Valley. Prior to his death on May 25, 2015, he regularly made presentations to schools about the 1915 genocide. He crusaded to the White House to ensure recognition for the Near East Relief and Armenian Orphan Rug, helped dispatch medical supplies to Armenia, served on multiple boards, held many leadership positions in the church, and acted as a big brother for 44 years. These and his multitude of other crusades, religious endeavors, and humanitarian activities earned him numerous awards, including the St. Nerses Shnorhali Medal and a gift of appreciation from the Armenian Genocide Commemorative Committee. (Courtesy of Tom Vartabedian.)

The daughter of Armenian immigrants, Rose Narzakian embodied the lifeblood of the Lowell Armenian Relief Society as a true humanitarian and visionary before her death in 2015. Whether it was collecting food and supplies for relief victims, tending to a booth at the Lowell Folk Festival each July, answering the call of duty, or delving into her purse to aid a cause, Rose symbolized the very best her organization represented. Chapter Lousintak is named after her mother. (Courtesy of Tom Vartabedian.)

Gary Koltookian (left) and Paul Sookiasian joined together to create a memorial for the only known Armenian to have served in combat during the American Civil War, Khachadour P. Garabedian. The memorial was unveiled in Philadelphia. Paul was inspired to raise funds for the memorial after reading an article by Gary in the *Armenian Mirror-Spectator* in 2004. (Courtesy of Gary Koltookian.)

Sara Jaffarian devoted her life to the welfare of library sciences. She joined First Lady Laura Bush (right) for a library fundraiser in 2005 following Hurricane Katrina. For 63 years, Jaffarian presented awards to schools with exceptional library programs; and also received multiple awards herself. She lived alone, never married, and her dream was that her treasure trove of photographs and historical documents would be preserved. This dream was achieved in the Sara Jaffarian Reading Room at the Haverhill Public Library. (Courtesy of the Jaffarian family.)

The Armenian National Committee of Merrimack Valley honored journalist David Boyajian (center) for his dedicated service to the Armenian community in articles that voice the Armenian cause. Activist Pearl Bargamian Teague (left) is joined Joseph Dagdigian (right), both former chairpersons of the group. The Armenian National Committee offers political support to the community and keeps government officials informed of activities both in and outside America. (Courtesy of Tom Vartabedian.)

At one time, the Merrimack Valley housed three chapters of the Armenian Relief Society—Haverhill, Lawrence, and Lowell. Auto magnate Alice Jaffarian of Jaffarian Volvo & Toyota not only presided over the Haverhill chapter throughout two decades but conducted summer cookouts at her Haverhill home, where guests were treated to a horticultural bonanza as well as an ambitious vegetable and fruit garden boasting sumptuous blueberries. Out of the garden came delicious pastries, which she shared with all. (Courtesy of Steve Dulgarian.)

The Haverhill Committee of the Armenian Revolutionary Federation is shown in the late 1960s or early 1970s. Members joined with the Armenian Relief Society in conducting dinners and commemorations at their River Street site, meeting with city officials to keep them abreast of the Armenian cause and preserve the political spirit in this city where many sought employment after emigration. The sole surviving member is Tom Vartabedian (back left), who currently belongs to the Lowell Committee and is celebrating his 50th year with the organization. (Courtesy of Tom Vartabedian.)

Tom and Nancy Vartabedian celebrated their 40th wedding anniversary while on a pilgrimage to Armenia with a group from the Merrimack Valley. They spent two weeks in Armenia, ending with a visit to Lake Sevan and the 800-year-old Sevan Monastery (pictured). During this time, Tom decided to write about his pilgrimage. He volunteered for 46 years as a columnist and correspondent with the *Armenian Weekly*, where he has written over 643 articles. His photographs have been published in the *Haverhill Gazette* and *Armenian Weekly*. Every year, he helps with the publication of a special issue featuring the Armenian Youth Federation Olympics and photographs the athletes. He has won multiple awards for his writing and photography. Tom retired from the *Haverhill Gazette* after 40 years. (Courtesy of Tom Vartabedian.)

Azniv Kasanjian Kazajian (middle row, third from left) survived the Armenian Genocide and settled in Haverhill with her husband, Haig Phillip Kazanjian. She raised two children, who were active in the church. Upon her death in 1950, at age 61, she was buried in Linwood Cemetery. The Armenian Relief Society provided comfort, assistance, and support to the Armenian community while helping to ensure that Armenian traditions were remembered. (Courtesy of Virginia Chobanian.)

Aurelian Mardiros (left) and Jack Medzorian stand by some of the $425,000 in medical supplies sent to Armenia by the North Andover Knights of Vartan. This is one of seven shipments sent that in total account for over $3 million in contributions. These included medical equipment, office equipment, and more to enable the International Medical Equipment Collaborative to upgrade hospitals and medical centers around the world. Jack was one of the coordinators and has worked with the group for over 20 years. (Courtesy of Tom Vartabedian.)

Eight

DEFENDING HOME AND HOMELAND

There were 10,000 Armenian volunteers in World War I and an estimated 400,000 in World War II, half of whom never returned home. Merrimack Valley sent its share of soldiers to the war who made the ultimate sacrifice in defense of their adopted country. These servicemen fought for the freedom that was not afforded to their native country, grim and gruesome as their fates were for them and the families they left behind. Many said their good-byes in their native language and bore ethnic names.

In these pages are a teenager from Methuen who gave his life in Vietnam, recognized by the military four decades later, and an individual who served in Normandy out of high school and went on to secure a college degree at the ripe age of 91. These heroes represent the motto, made famous by Rotary International, of "service above self." What strikes an emotional chord is the fact that nearly all these recruits and enlistees were the children of refugees or immigrants themselves. Their dedication and supreme service to a country that opened its doors make an ineffaceable impact upon the people they defended.

Pictured around 1920 is either a Memorial Day or Fourth of July parade with World War I veterans on State Street in Newburyport, Massachusetts. The flag bearer (front center) may be carrying the Armenian tricolor. Newburyport, a small coastal town north of Boston, was home

to a number of Armenian families. (Project SAVE Armenian Photograph Archives, courtesy of Hagop Bedrosian.)

Mardiros Jingirian was an Armenian native who lived in Lawrence, Massachusetts. Mardiros served in Ararat at the Vartan Camp as part of the Armenian Church, dedicated to ensuring health and safety of the community. He faced death during the Armenian massacre, where he witnessed the Ottoman Empire slaughter men, women, and children. He is pictured in full combat gear, which shows his position in ensuring the Ararat people were safe. (Courtesy of the Armenian Library of America.)

Pictured in full combat uniform is Sgt. Antreas Minassian, who was based in Lawrence, Massachusetts. Antreas served Armenia well in war, guiding the Armenian unit to fight the Ottomans. Serving in the Armenian Genocide period, Antreas and his unit gave all they had to protect their country and its people. (Courtesy of the Armenian Library of America.)

Mardiros Jingirian (left), later killed at Ararat, and Stepan Piligian, who later lived in Lawrence, are pictured. Mardiros and Stepan lived in Ararat with their family before Mardiros was killed. Stepan was an active community member on matters of faith, serving under the Armenian Church. He was chairman of the parish council Armenian Church of the Holy Translators and played a vital role in uniting members. Stepan volunteered to be a religion teacher at Vartan Camp. (Courtesy of the Armenian Library of America.)

Sarkis Der Katchadourian, later of Haverhill, was among the Armenian troops in the Légion d'Orient. The decision to incorporate the Armenian unit with the French army created the disastrous outcome of the Gallipoli Campaign. Sarkis operated under the additional units, acting as a ally to the Russian army, which was believed to have made a move on the Ottoman Empire from south Cilicia. The Légion d'Orient (Eastern Legion) was to occupy the Cilician territories in 1917, as the French army based there was weak. (Courtesy of the Armenian Library of America.)

Asadour Boghosian, later of Lowell, is pictured in a full uniform of the Armenian unit. Asadour lived in Lowell with his family and died there. The Boghosian family fought in the Armenian Genocide, protecting women, children, and property. Asadour was a brave soldier and an active member of the Armenian Church, which was dedicated to uniting the Armenian people. (Courtesy of the Armenian Library of America.)

Nishan Menasian earned this $20 Armenian Revolutionary Federation bond to use for living expenses in 1920. Nishan was a small farmer who provided vegetables for local families. In order to supplement his meager farm income, he also worked at the mill. Money from the bond also helped his wife and five children. Nishan was hit and killed by an out-of-control car in 1964. (Courtesy of Maureen Dadekian.)

This Armenian Red Cross postcard shows a warplane and a cavalry charge (at top). The Armenian Women of Nashua were in charge of treating wounded Armenian soldiers. A Red Cross nurse is shown taking care of a soldier who seems to have been wounded in battle. (Project SAVE Armenian Photograph Archives, courtesy of Alice Keosian.)

117

Boston, Mass.,
Sept. 13, 1923.

Veteran's Bureau,
Washington, D.C.

My dear Sirs:

This is to certify that Bagdasar K. Chooljian was wounded while serving as a private in Company L, 102nd Infantry. Mr. Chooljian was struck by a machine gun bullet while advancing with his Company in the attack at Boureshes, during the Second Battle of the Marne on July 20th. He was taken to the hospital after lying in a wheat field for several hours during which time he suffered intense pain and agony and lost considerable blood. He was unconscious for at least three hours after he was struck.

Mr. Chooljian joined Company L together with other replacement troops on the night of April 20, 1918, during the Battle of Schieprey. He like every other man that came with the replacements was unfit for front line duty. He had been sent to France, together with these other men to work in the Service of Supply, and not for front line duty. Mr. Chooljian was suffering from flat feet when he joined the Company, but owing to a drastic order that had been issued by the Commander in Chief of the Army to keep men at the front, he was not relieved from duty. At all times that Mr. Chooljian was with Company L he limped about with the assistance of a cane. The medical records of Company L will show that he was treated constantly by the battalion surgeon for this disability.

Despite his handicap Private Chooljian served willingly and was considered one of the best soldiers in the Company. He was about to be promoted to the grade of corporal when he was wounded.

Paul H. Hines
Formerly 1st Lt. and
Comdg. Officer Co. L, 102nd

Then personally appeared Paul H. Hines and made oath that facts contained in this letter were true to the best of his knowledge and belief.

James F. Higgins
Notary Public

This photograph shows Bagdasar Chooljian's wounded-in-action letter. After immigrating to Haverhill, Massachusetts, Bagdasar joined Company L of the 102nd Infantry in World War I and was wounded by a machine gun bullet during the Battle of the Marne. Bagdasar was a war veteran who never let his handicap limit his contribution in the battle. The letter recognizes his bravery and dedication in the fight and reveals that he was about to be promoted to corporal. (Courtesy of Diane McIntosh.)

This immigration document was issued to Bagdasar Chooljian in 1921. The document is a passport declaring Bagdasar as the bearer and indicating the countries he was allowed to visit. While serving in Company L, Bagdasar was sent to France, one of the countries the document specifies; others include Greece and Italy. Pictures of him and his wife, Shooshan, are included on the document, representing permission for his wife to accompany him into the specified countries. (Courtesy of Diane McIntosh.)

119

Nishan (left) and Levon Amirian served in the military during World War II. Levon entered the Army on August 7, 1942, and was discharged July 24, 1943. Nishan entered the Army Air Corps on June 5, 1942. Neither ever married or had children. Nishan worked as an athletic trainer for most of his life, and his career allowed him to work with many of the Boston professional sports teams. Levon worked at Western Electric until retirement. (Courtesy of Sven Amirian.)

T.Sgt. John Nazaretian was employed as a machinist for the Frank C. Meyer Company of Lawrence at the time he enlisted in March 1941. John was mortally wounded by a sniper's bullet on January 25, 1945, close to Weicherdange, Luxembourg. He was on a mission to secure more ammunition for his men, who at the time were under attack from all angles by the Germans. John is buried in the American Military Cemetery in Hamm, Luxembourg. (Courtesy of the Haverhill Public Library.)

Cpl. Simpat Poshian was killed in action in 1945 in Germany. Simpat also fought in Alsace-Lorraine, giving up his corporal stripes for the opportunity to go abroad. Before entering the Army, Poshian was employed as weaver in the Pentucket Mills of Haverhill. (Courtesy of the Haverhill Public Library.)

121

John "Kaz" Kazarosian was the treasurer of the Wilbur M. Comeau Post No. 4 of the American Legion. He was an Army veteran of World War II and joined the Navy during the Korean War. John was instrumental in organizing parades in Haverhill on Memorial Day and Veterans Day and was known as "every veteran's best friend." In his civil life, he worked 32 years in the aeronautic division at General Electric in Lynn, Massachusetts, and was also a proud member of the city's Masonic organizations. (Courtesy of Tom Vartabedian.)

Sgt. John H. Boyajian was mortally wounded on May 30, 1944, in the Battle for Rome in World War II while carrying out his duties as the section leader of a light machine gun section. Before he was enlisted, John graduated from Thornton Academy and Boston University. He was also previously employed by the Stephen Shoe Company. He left behind his wife, Aura Boyajian, and his child, Harry, along with his parents, Harry and Marie Boyajian. (Courtesy of the Haverhill Public Library.)

Alton Dadekian Krikorian is seen with her brother Martin Khachador Dadekian on the Army base before he was deployed. She tried unsuccessfully to get him out of the Army by writing to senators. A clever lady, she did not sign "Mrs." in an effort to get more respect. She thought they might mistake her for a man since Alton is a man's name in English. (Courtesy of Maureen Dadekian.)

Harold Paragamian is pictured holding the liberal arts degree awarded to him in 2015 by Merrimack College in North Andover. After taking the advice of his parents, which was to make the most of his life and not be idle, Harold made a point of earning a college degree in spite of his 91 years of age. Apart from studying, Harold worked in the military for four decades as a civil service employee in the Army Post Exchange at Fort Devens in Ayer, Massachusetts. Even today, Harold enjoys walking and visits auctions and hobby shops to help him tend to his model train collection. (Courtesy of Tom Vartabedian.)

David Bedrosian (1949–1969) was the son of John and Margaret Bedrosian of Lawrence, Massachusetts. As a teenager, he served his Holy Cross Armenian Church regularly, helping neighbors and delivering food and clothes for the indigent. He was a model student who planned to attend Wentworth Institute and become an architect. He chose to put his education on hold to serve in the US Army during the Vietnam War. Six months after enlistment, he was shipped overseas to serve in the infantry in Vietnam. He was killed on November 14, 1969, in Binh Long by his own vehicle in an accident. His funeral was the largest military gathering ever seen in Lawrence. In 2011, the military memorialized him with a shrine inside the Methuen City Hall foyer. In 2015, he was posthumously awarded the Medal of Liberty. (Courtesy of the Bedrosian family.)

Pictured are, from left to right, (first row) Serpouhi Bedrosian, Julia Arakelian, and Yeghia Bedrosian; (second row) Aghavni Kochakian, Garabed Bedrosian, Manoug "Mike" Bedrosian. Aghavni lived in Lawrence and Methuen, and was a member of Ararat Congregational Church. Garabed was a paratrooper in the Army during World War II and also was a prisoner of war. He lived in Lawrence and Methuen, and was a member of Holy Cross Armenian Apostolic Church and of the Habousi Compatriotic Union. Garabed was also the owner of Capitol Cleaners. Mike lived in Methuen and served in the Army during World War II. He worked at Western Electric. Serpouhi Bedrosian lived in Methuen. Yeghia worked in Lawrence mills and was a farmer in Methuen. He was a founding member of Holy Cross Armenian Apostolic Church and a founding member of Habousi Compatriotic Union. (Courtesy of Danny Bedrosian.)

Margaret Bedrosian holds her son David Bedrosian's Medal of Liberty. It was awarded by the US Army in a special exercise 46 years after David's death in Vietnam at age 19. Margaret was joined at the ceremony by many family members. This award came four years after the US military memorialized David in a Lawrence City Hall foyer shrine where others who made the ultimate sacrifice are also memorialized. Margaret said, "David's alive in our hearts, never dead. . . . In our mind, David has never left home." (Courtesy of Tom Vartabedian.)

Maj. Felix Gregorian is pictured on his fourth tour of duty in Afghanistan. He immigrated to the United States from Iran. A soldier enamored with his career, he did not realize he would be deployed to such hostile land so many times. Felix has been a member of the Army for over 20 years and finally retired after completing a fifth tour of duty. In civilian life, Felix is a respiratory therapist and has even volunteered as part of a medical team that treats children needing cardiac care in Africa. (Courtesy of the Gregorian family.)

125

Brothers Dro and Greg Gregorian distinguished themselves as scholar-athletes at Chelmsford High School, became stole bearers at St. Gregory Church of North Andover, and proceeded to military schools at Annapolis and West Point. Both are currently active in the military, following in the footsteps of their father, Felix, who recently finished five tours in the Middle East under combat situations. The Gregorians remain an ultimate military family in the Merrimack Valley. (Courtesy of the Gregorian family.)

The Armenian Martyr's Memorial at Sts. Vartanantz Armenian Church was dedicated in 2005 on the occasion of the 90th anniversary of the Armenian Genocide, through a generous donation by William Hausrath in memory of his late wife, Agnes. The focal point of the monument is three stone crosses (called *khatchkars* in Armenian) representing men, women, and children—all victims who perished during the genocide. The benches are dedicated in the memory of donor families and are divided into two groups—those who perished during the genocide, and those who survived or are descendants of survivors. (Courtesy of Sts. Vartanantz Armenian Church.)

Nellie Nazarian admires the new genocide memorial at Lowell City Hall, taking her venerable place as the last survivor in Merrimack Valley. Nellie escaped the massacre in her native village of Chimisgazag by taking refuge in the mountains. Those hands on the stone could very well have been her own, symbolizing the miracles of motherhood and dexterity. At the age of 102, she died in June 2014, shortly after this photograph was made. (Courtesy of Tom Vartabedian.)

127

DISCOVER THOUSANDS OF LOCAL HISTORY BOOKS
FEATURING MILLIONS OF VINTAGE IMAGES

Arcadia Publishing, the leading local history publisher in the United States, is committed to making history accessible and meaningful through publishing books that celebrate and preserve the heritage of America's people and places.

Find more books like this at
www.arcadiapublishing.com

Search for your hometown history, your old stomping grounds, and even your favorite sports team.

Consistent with our mission to preserve history on a local level, this book was printed in South Carolina on American-made paper and manufactured entirely in the United States. Products carrying the accredited Forest Stewardship Council (FSC) label are printed on 100 percent FSC-certified paper.

MADE IN THE USA